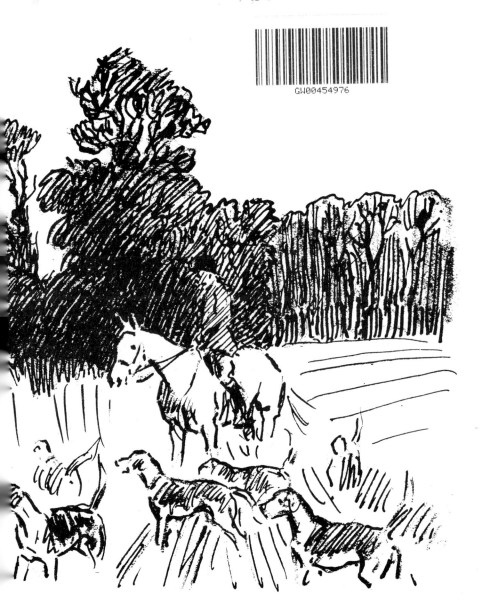

Figures In A Landscape

Lionel Edwards, R.I., R.C.A.

A Sporting Artist and his family

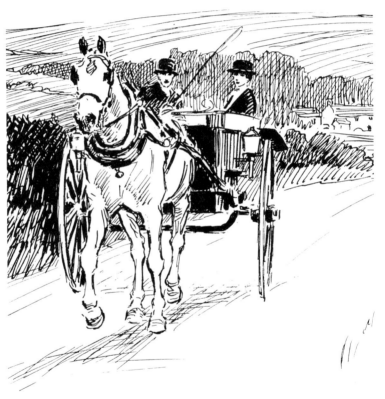

Lionel and Ethel go to the meet in their trap.

Figures In A Landscape

Lionel Edwards, R.I., R.C.A.

A Sporting Artist and his family

by

Marjorie Edwards

Foreword by The Hon. Aylmer Tryon

Marjorie Edwards

Regency Press (London & New York) Ltd.
125 High Holborn, London WC1V 6QA

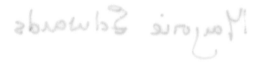

ISBN 0 7212 0771 5

Printed and bound in Great Britain by
Buckland Press Ltd., Dover, Kent.

List of Illustrations

All illustrations, other than photographs, by Lionel Edwards.

Acknowledgement

I wish to express my thanks to the Hon. Aylmer Tryon for so kindly writing the foreword, to my family for their encouragement and especially to my sister-in-law Claire for all her help. Also I am very grateful for being allowed to read the many letters my father wrote to Peter Biegel and to the late Denis Aldridge.

Foreword

Lionel Edwards's autobiography, *Reminiscences of a Sporting Artist*, is a fascinating account of his early training and subsequent development into the best painter of the hunting scene of his day. This biography is an account of the man himself, of his devoted wife and family without whose help and encouragement he would never have attained such happy and successful fulfillment of his ambitions.

A sporting artist however skilled can never convey the true fascination and excitement of field sports unless he or she is a true countryman and really understands and enjoys these sports and has an eye for the country in fair weather and foul, and can capture the 'atmosphere', the key to his success.

Lionel Edwards was a modest and unassuming man yet patient and determined who probably hunted with more packs of hounds throughout these islands than anyone else has ever done. He seemed impervious to cold and I have seen his sketch book smudged where snow had fallen or more often by rain. These pencil sketches were the key to his success, his eye and memory recalling the scene as he transferred it to paper or canvas. Thus a scene for the picture of a particular hunt would include action portraits of the leading hounds of that kennel, members of the hunt often recognisable instantly by the 'seat' of the rider and even certain knowledgeable foot followers, who can be seen by their attitude, as they lean on gate or tree, could tell the huntsman where he made a false cast.

A 'Lionel Edwards sky' is an expression still used and like all true countrymen he looked to the sky to forecast weather and scenting conditions before the days of satellite pictures. No one has captured so well a good scenting day and I recall an Irish scene 'Nobody with them' with hounds scarcely visible in the distance, the field straggling far behind, or 'Nothing stops 'em' as a couple of intrepid Irishmen balance

on top of a great bank leaving their horses to negotiate the obstacle. And then, returning to kennels on a wet November evening as darkness begins to fall with huntsmen, horses and hounds obviously tired but contented after a long hard day. No wonder that his prints have been so popular over the years for the memories they recall.

Perhaps the most satisfying of his many books are his sketch books whether *The Shires and Provinces* or *My Scottish Sketch Book* whilst I have a preference for his watercolours, so difficult to achieve but so memorable, of a fox hunting scene.

Leicestershire with its beautifully cut and laid fences, small fields—in those days with scarcely an arable field in sight, is rather flat country, ideal for the huntsman but difficult for an artist to record a satisfactory view. Lionel Edwards therefore whilst preferring to hunt over such country, artistically preferred the more colourful Exmoor scene with perhaps a distant glimpse of the sea. He delighted too to depict deer forests of Scotland and one of his last pictures was of such a scene with fresh fallen snow on the tops. I remember this particularly since he went up late in the season wishing to be at home for his diamond wedding.

Lionel was never a wealthy man, nor probably would he have wished to be, but at least by his skill earned sufficient for his family and to keep a couple of horses as models and to hunt. In his day it was difficult for a sporting artist, even of his stature, to charge large sums for a commission but he certainly derived great satisfaction from a successful exhibition. Nowadays with the increased appreciation of art a young sporting artist with sufficient skill may earn a considerable sum of money. The pictures of Lionel Edwards and his contemporaries have belatedly greatly increased in value, and I hope that this at least gives pride to his surviving family.

The racing scene was in his estimation secondary to hunting, but his great ability to paint movement which he studied most carefully and with the freedom with which he applied his brush succeeded in capturing the speed of the racehorse and the excitement and atmosphere of the racecourse, although a point to point was perhaps nearer to his heart.

My home is less than half an hours drive from Buckholt and thus I was fortunate enough to visit there frequently and listen enthralled by his tales of his early days; studying in London where he shared a studio with Gilbert Holiday—"a very untidy man," he would say, as he delved

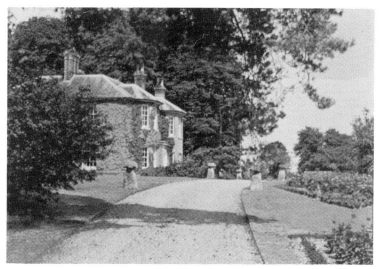

Buckholt House.

in an old ottoman full of sketches and photographs finally holding up a faded photograph of an old lady milking a cow in the Green Park, to show me the then equivalent of a Milk Bar. Once he came into the Gallery with a black eye. When I enquired how this had happened it transpired that he was out riding when he happened to meet hounds and collided with a branch in the course of the ensuing hunt. He had to drive some twenty miles to a distant doctor, his own having forbidden him to hunt because of his age—well into the eighties. Nothing stopped him!

Marjorie Edwards's delightful biography of her father, mother and family recalls the difficulties of early days and brings out the strength of character which finally became a success story so well told which will delight his numerous friends and many too young to have known him except as an almost legendary figure.

The Hon. Aylmer Tryon

Introduction

I must begin by stating that this book is not a biography of 'Lionel Edwards, the well-known sporting artist'. That would be a task for which I have not the capability and am therefore unfitted to undertake. This is just a memoir, which, according to *The Concise Oxford Dictionary* is a 'record of events' and a 'history written from personal knowledge or special sources of information' of two people who, because I have always lived at home, I knew well, namely my parents Lionel Edwards a sporting artist, and his wife Ethel.

I realise that some of the events recorded read rather like Victorian melodramas, but I have recounted them as they were told to me, and have no reason to doubt their accuracy. They remind us of the tremendous changes, accelerated by two World Wars, that have taken place between the England of the beginning of the century and the England of today.

I regret that I have no doubt omitted to mention some matters of importance relating to Lionel's art, and have certainly been unable to include the names of many of his best friends and clients. But I think the latter was inevitable and hope they will forgive me.

Lionel's family background is described in one of his own books, *Scarlet and Corduroy*, in which he says, 'I have always been given to understand that the family originally came from Chirk, Denbighshire, but the first records I can find are of two 'Black Squires' who lived respectively at Prestbury in Gloucestershire and Ashford in Kent. The former of these, the Rev. William Edwards (later vicar of Tarvin) married Eleanor Gamul, fifth daughter of William Gamul of Crabtree and sister to Sir Francis Gamul. From this union our branch of the family descends. We have the contemporary portrait of Sir Francis and the stick Charles I gave him, or we had until comparatively recently when the latter disappeared, presumably stolen. It was a black ebony stick with several brilliants in the handle and a tassel. Sir Francis does not look at all like a Cavalier in his portrait and is far from handsome. The King lodged with him the night of 24th September, 1645 at his house in Lower Bridge Street, Chester, and on 25th September Sir Francis watched the battle of Rowton Heath from the north-east corner of the walls of Chester while in attendance on His Majesty. During the fight his son, aged eighteen (of whom I also have a portrait as a child of three, and very ugly he is!) was killed when the Roundhead musketeers defeated the Royalist Cavalry.*

The aforementioned William Edwards had several children. One of them, Thomas, had a son, also Thomas, who became vicar of Aldford and chaplain to the Marquess of Westminster. He married Mary Ann Robertson of Edinburgh, who was a friend and pupil of George Romney, and as far as I can trace, the only member of the family with artistic ability. My own, such as it is, presumably comes from her, having skipped a generation, although I believe my father could draw

*See Ormerod's *Chester*.

quite well. He often used to say that as a medical student he had been
hauled over the coals for sketching during lectures!

Although it seems incredible, Lionel's father, James Edwards, was
born in 1810, five years before the battle of Waterloo. He was the fourth
son of the Thomas Edwards already mentioned, and became a doctor of
medicine (Liverpool and Edinburgh) practising in Chester as a
specialist in stomach troubles. His first wife was Jane Main, by whom
he had four children, two of whom died in infancy. The remaining two
were Robert William Gamul and Mary Jane. Gamul, as he was always
known, died young, but Mary Jane lived to a great age.

Robert Main, Jane's father, had made a trust for his two daughters, of
which Jane received five thousand pounds. Dr. Edwards bought St.

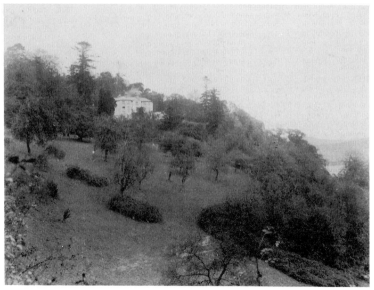

Benarth.

John's House in the parish of St. John the Baptist in Chester, using two thousand of the trust money to do so. A deed survives allowing him to live on in the house if his wife died, which she did in 1845. In due course he married again, Eliza Ellen Smith, but she died in childbirth and little is known of her. After the death of his second wife he left Chester and bought a property, Benarth Hall, in Wales, from which he used, being well off in those days, to go away to fish at Fairford and hunt with the Warwickshire.

Gamul, the doctor's only son, died in 1856, leaving him with his daughter Mary Jane, to whom he was devoted, but with no heir to the estate. Mary was lonely and miserable without Gamul and her father decided that she must have a companion of her own age. He accordingly asked a young relative, a cousin of his first wife, to come and stay at Benarth. Harriet came from Kelso, a considerable distance from Wales, and as was the custom in those days, the visit lasted indefinitely. Harriet Main was not clever but very pretty, vivacious and amusing, not at all like the serious-minded and religious Mary, but the two became great friends. Mary was twenty and Harriet eighteen.

Harriet stayed on and on at Benarth and already felt herself one of the family, when the doctor, partly because he had become fond of her and partly because he wished for an heir, asked her to marry him. He was an attractive and charming man, and this, together with the fact that Harriet, who had been brought up in modest circumstances, enjoyed the prospect of being 'the wife of Benarth' as the Welsh say, persuaded her to accept him. Her very beautiful half-sister Jane, who had married her first cousin Henry Main, later Sir Henry Main, led a very fashionable life in London, a life which Harriet felt she would now be more likely to be able to share.

So the marriage took place and in due course Harriet presented the doctor with five sons, FitzJames, Arthur, Henry, Frank and finally, Lionel.

Sadly, after Dr. Edwards's marriage, he seems to have lost all interest in his daughter Mary, and after her own marriage to Philip Peters (of the firm of coach builders) she rarely returned to the home she loved so much. It says a great deal for her generous nature that she never seems to have grudged the place Harriet and her sons had usurped in her father's affections.

CHAPTER TWO

Lionel Dalhousie Robertson Edwards was born on 9th November, 1878, somewhere in or near Clifton, where his mother was staying either in lodgings or with one of the numerous Edwards or Main relations. Dr. Edwards, aged sixty-eight, now had four sons and it is doubtful if the birth of a fifth interested him particularly. He and his young wife led separate lives by this time, he at Benarth and Harriet, hating the country and bored and lonely now that her elder sons were away at boarding school, was never at home if circumstances permitted her to be somewhere else. She preferred to stay with or near her sister Jane Main—Lady Maine as she had now become, after her husband had been gazetted K.G.S.I. in 1871. The Maines lived in London, in Cornwall Gardens. Sir Henry worked at the India Office until 1877, when he became Master of Trinity Hall and had a second home, the Lodge in Cambridge. Honours had fallen thick upon him as 'the great English jurist', among them membership of the Royal Society. As early as 1862 he had been elected to the Athenaeum under a rule which permits nine persons of eminence to be elected to the club every year. To dine with the Maines therefore was to anticipate meeting some of the great men of the day, Lord Randolph Churchill, Lord Salisbury, Robert Browning, Cardinal Manning, Edward Lear and many others. Some of their letters to Sir Henry or Jane are still extant,* among them a pathetic letter from George Eliot thanking Sir Henry and Jane for their sympathy after the death of George Lewis, and a long one from Edward Lear, part of which reads as follows: "I have read your paper about 'Silly Bits' with much pleasure. It is certainly very funny and I suppose all true about consequences, but of that I can't judge. Only I distrust the proverb about 'Gripping fleas in haste'. That is a mistake.

*In the possession of my brother, Kenneth Edwards.

An experience of over fifty years in Italy and other psyllic (sic) lands has taught me that *slow* movements with a wet finger-tip is the proper course of action."

Jane Maine was beautiful and Harriet pretty and vivacious, and Jane's parties were famous, but neither appreciated the intellectual qualities of their guests as did Eliza Main, Harriet's other sister. A tall, gaunt, plain woman, she was Harriet's opposite in every respect. Fluent in French and German, she was addicted to the more melancholy of the German philosophers, and kept up a lengthy correspondence with many contemporary men of letters. Having just enough money not to have to earn her own living as a governess, she spent her time in writing and in due course published two rather dull novels. Harriet, who could be flighty and thoughtless, was always prepared to be completely unselfish with regard to her sister 'Liz'.

Lionel accompanied his mother everywhere and never had either a nanny or a nursery, but lived among adults in a world of his own, peopled from his earliest days by horses and soldiers. He would lie on his stomach on the floor for hours on end drawing on any piece of paper that came to hand. As a small boy he enjoyed being at Benarth, where his father and elder brothers made much of him and he was spoilt by the servants. There is a story that one day Margaret, who lived in one of the lodges and worked in the house when required, brought her three-year-old daughter Grace with her and left her on the verandah to play with the five-year-old Lionel. Later, hearing piercing screams, she returned to find the little girl tied to the iron railings.

"Whatever did you do that for, Master Nello?" she asked.

"She is my horse," replied Lionel calmly. "What a good thing real horses don't make that noise when they are tied up."

Many years later Grace accompanied Lionel's family when they moved into England during the First World War and became not only a great friend, but its mainstay, being nanny, cook or landgirl as circumstances required.

Incidentally, there was some rhyme about 'Punchinello, little fellow', with which his brothers teased Lionel, and throughout his life he was always known as 'Nello' to his family. Lionel's only playmate when he was at Benarth was Arthur Wood, the son of Albert Wood of Bodlondeb, a house near Benarth on the outskirts of Conway. Arthur was a year or two older, very musical, but not a country lover, and with a bad stammer which made him shy. However they became and remained

friends throughout their lives. When Lionel was eight his father died, leaving Harriet with very little money to provide for herself and her five sons. Arthur's father, Albert Wood, a rich man and a great collector of pictures, recognised Lionel's talent and offered to adopt him, pay for his schooling and later send him to Paris for his artistic education. Lionel, however, not unnaturally, refused to be 'adobbed' as he called it, and probably his mother had no real intention of allowing him to leave her.

Fitz and Arthur, the older two of Lionel's brothers, had both been at Charterhouse, but Arthur, who was two years younger, was the cleverer, and it was thought wiser that he should be removed and sent to Clifton. Fitz, after leaving school, went to Sandhurst to commence a brilliant career in the Army. There is extant* a letter from Sir Garnet Wolseley to Sir Henry Maine, Fitz's godfather, saying that, "There is no difficulty about Lieutenant Edwards transfer to the 2nd Battalion of the East Surrey Regiment, and I have given orders that it shall be carried out at once, but he will, of course, not embark until the trooping season commences." Fitz was, however, already abroad when his father died.

Arthur, both handsome and wild, spent two or three hectic years in London, then became manager of a slate quarry near Portmadoc, married, and settled down to a happy but undistinguished life as a country gentleman. Harry, the next son, refused to take up any of the careers suggested to him as suitable for a gentleman and spent his time at Benarth, shooting and fishing, and frequently joining the local poachers (some of whom were his mother's tenants) in forays on to the adjoining estates. It was embarassing for the magistrates to have a son of their neighbour, the widowed 'wife of Benarth' brought before them, and at last Harriet decided something must be done and Harry was sent to Canada. Here he married and did extremely well, returning occasionally, and keeping up a desultory correspondence with his mother and brothers.

The fourth son, Frank, intended to be an artist and was sent in 1886 to the Hubert Herkomer School. He was a very good draughtsman judging by the few sketches which remain, but was not yet twenty-one when he died of cholera while staying with Fitz in India.

The two elder ones were undoubtedly Lionel's favourites, and they were extremely fond of him, treating him more like a son than a small

*In the possession of Kenneth Edwards.

brother. Fitz was his hero, being in Lionel's eyes everything a soldier should be. The stories he related of life in India at that period—surely the most wonderful life the Army has ever provided for its soldiers—remained with Lionel for ever. Fitz was a very fine horseman and excelled both at pig-sticking, winning the Guzerat Cup, and at polo. There is a lively sketch of pig-sticking done by Lionel when he was about seven years old. The pig is rather large and the horses rather small, but full of life and movement. Lionel's first hunting picture was painted at an even earlier age. Many years later he gave it to his great friend Captain Jack Gilbey, who said of it when it was reproduced in *Country Life*, "When I showed the original water colour, which measures five inches by seven, to an expert, he remarked, 'You can see that the artist is born, not made.' As one would expect, apart from the two trees in the foreground, there is not much detail in the composition, but the huntsman and his horse are alive, and there is distinct action in the hound."

Arthur was Lionel's guide, philosopher and friend until the former's death from a heart attack while fishing, in 1922. According to Ethel he was, apart from herself and his mother, the person Lionel loved most. One of his books is dedicated, "To the memory of A.G.E., an impecunious gentleman who loved salmon fishing and helping lame dogs over stiles, both expensive pursuits."

Although Arthur could never imbue Lionel with his love of fishing—too quiet and peaceful a sport for one who loved excitement and action—he did impart a great love for and knowledge of the countryside and its inhabitants, both animal and human. It was entirely due to Arthur that Lionel became the very good naturalist that he was, which is so observable in his sketches. It was, however, to the Welsh weather that he always attributed his ability to paint rapidly in watercolour, for in the mountains, if one is not quick, the scene has changed within minutes. As he grew older, days were spent walking with Arthur, either to go beagling or to some place where Lionel would sketch while Arthur fished.

As regards education, considered as 'the three R's', Lionel always maintained that he owed everything to 'Aunt Liz', his mother's sister, who was a frequent visitor both to Benarth and to the various lodgings in which they so often found themselves. It was Aunt Liz who taught him to read, impressing upon him that if one could read one's education was then in one's own hands. This was certainly borne out in his case,

for constantly moving from place to place, Lionel never had any formal
education. History became one of his favourite subjects and in time he
knew a great deal about those periods in which he was interested—but
nothing at all about those in which he was not. The conquests of the
Roman armies, the battles of the Civil War—he was an ardent Royalist,
perhaps because of his ancestors—the rebellions of 1715 and the '45,
and perhaps most of all, the Napoleonic Wars, about all of these he read
extensively. Later he became a Kipling addict, knowing many of the
stories and poems by heart. But as for music and mathematics,
particularly the latter, they remained unknown territories for him
throughout his life.

At a time when it was still considered that an artistic career was not
suitable for a gentleman, it is to Harriet's credit that she never opposed
either of her sons in their wish to become artists. This was partly, no
doubt, because at the Maines she met both artists, actors and poets, as
well as men of letters.

When Lionel was ten or eleven and they were in lodgings once again,
because Benarth was let, Aunt Liz died of cancer. Throughout a long
illness she was nursed by her younger sister. No one thought it strange
that Lionel should sleep at night on the couch on which Aunt Liz had
lain all day, but it is to this period and to the fact that many years later
his mother also died of cancer, that Lionel owed his lifelong dread,
amounting almost to terror, of this disease.

So childhood passed for a solitary but not lonely boy, both indulged
and neglected, but like Beatrix Potter, happy in his imaginings and in
his ability to portray these imaginings on paper.

CHAPTER THREE

Lionel and Ethel first met when he was seven and she was four. They disliked each other on sight, and the relationship was not improved when, in November, they were told to go to look for blackberries while their respective parents exchanged family gossip. The two families were distantly related in that both had Main connections. Lionel's mother was a Main and Ethel's great aunt Eliza Routledge had married a George Main of the same family. However, the relations saw little of each other, and it was many years before Lionel and Ethel met again.

Ethel's mother, Mary Ann Pell Dainty, was the great granddaughter and heiress of William Routledge, Dean of Glasgow, who died in 1843. We have a charming portrait of him, a collection of sermons beautifully written in a copperplate hand, and an obituary notice, elegantly framed, which asks:

"Wilt thou in thought sometimes re-visit earth
And mark, with moistened eyes, our struggles here?"

He might well have done so, had he known the vicissitudes which were to beset the life of his great granddaughter.

Mary Ann was the only daughter of Jane Routledge and John Pell Dainty of Loddington Hall near Kettering, a beautiful Elizabethan house which was sold to Lord Overstone in 1859, to the great grief of Mary and her younger brother John. The brother and sister were very fond of each other and shared a love of poetry and foxhunting. The family presumably hunted with the Pytchley, since after leaving Loddington they lived in Kettering. Mary was an exceptionally fine horsewoman and legend has it that she used sometimes to school the horses ridden by the Empress of Austria when the latter hunted in the Shires.

In due course Mary married William Wells, a partner in a brewery which is now one of the best known in England. He was the younger

son, and his father doted upon him, handing over the business interests to him when he was twenty-one, and passing over the elder brother, George. George was a happy-go-lucky, roving ne'er-do-well who spent most of his life abroad, much of it fighting as a mercenary in Spain. William, unfortunately, was convinced that he was a business genius, without there being any indication that this was the case, a conviction which finally led his exasperated partner to dissolve the partnership.

For some years there was enough money, using Mary's as well, for them to live in comfort, William setting himself up in business on his own. They lived first in Epsom and then in Richmond. Mary had to give up hunting as she produced nine children in fairly quick succession. They were Henry, William, Mary, Maude (who died in infancy), Frances, Philip, Gerald, Ethel and a very delicate youngest son, Frank. They were a happy family, although the parents, who entertained a great deal, saw little of their children, who were brought up by a nanny, to whom they were devoted.

Ethel was born in 1881 at 4 Portland Terrace, Richmond, and always said that her earliest memories were of the time when she was about three years old. At this time Harry, good looking and clever, was at Harrow, first in Smallhouses and then in the Headmaster's house. He became the champion boxer of the school. His parents adored him, and he was usually allowed to have and to do whatever he chose. His chief companion during the holidays was his eldest sister Mary (always known as Cissie) who, like him, was handsome, with a lively mind and a quick tongue, and was extremely capable and energetic. William, the next one, was a quiet boy whose ambition was to do well enough in his studies to enable him perhaps to return to Harrow as a master when he grew older. Frances, who came next, was a quiet nondescript little person, a favourite with her parents, but greatly overshadowed by the two oldest ones, of whom she was very jealous. She was also jealous of the rather spoilt youngest ones, Ethel and Frank, a jealousy which sadly never left her and which spoiled her life. Two boys, Philip and Gerald, followed Frances, and of them no one, it seems, except Nanny, ever took much notice. Philip, a sturdy, serious boy, had but two loves in his life, Gerald and his books. His fierce, protective love for his brother often stood the latter in good stead at school, for under Harry's tuition, Philip also became a fine boxer. When Gerald was a very small baby, his nurse had stumbled going up some stone steps and had dropped him. He suffered brain damage from which he never recovered.

He was slow in understanding, hesitant in speech and nervous of everything and everybody.

It has been observed that sometimes in large families the parents tend not only to have favourites, but occasionally to have one child whom they either neglect or dislike or both. Gerald's parents seem to have been constantly irritated by his slow speech and inability to learn and were forever scolding him for his stupidity. The children, however, quick as all children are to recognise injustice, made excuses.

Ethel herself seems to have been a happy, placid child, fond of her older brothers and sisters, and especially of the delicate youngest one, Frank, who early showed signs of the tuberculosis he was to develop later.

In all of us childhood memories tend to focus with clarity on a few events which, perhaps because of their unfamiliarity or infrequency, seemed of great importance. So it was that Ethel always remembered how one night Harry brought friends home to supper and afterwards, his parents being away and Nanny in the kitchen, fetched her from her cot and carried her downstairs, where she danced in her nightgown on the dining-room table and then recited nursery rhymes. The boys laughed and clapped, she was given a sip of beer and then went to sleep on Harry's knee.

As in most homes in Victorian times the family world revolved around the master of the house, his comings and goings, his habits and his wishes. Ethel remembered how one afternoon she was sitting on the stairs with her brothers and sisters and several of their friends, watching a boxing match between Harry and another boy. Suddenly the key was heard to turn in the front door lock. There was utter silence as everyone made a swift exodus upstairs to the haven of the nursery, leaving their father to enter a hall as quiet and deserted as usual. Even when the children had been dressed to go down into the drawing room after tea, where their mother would read to them, this too stopped immediately their father entered the room and they would be sent back to the nursery. There was never any question of indiscipline in this family for though William was in many ways a kind and generous parent, he was very strict, as also was Mary. She ruled the older ones by the use of a biting scarcasm of which they were very much afraid, and the younger by punishments which, rightly, would be frowned upon today. Once, for some slight disobedience, she ordered that Willie, a rather nervous boy, should be shut in a dark cellar for two hours. Nanny, who strongly

disapproved, could not disobey her mistress, but sat the whole two hours just the other side of the door, talking to him and telling him stories.

During a period when the parents and children of the middle classes often saw very little of each other, it is not surprising that parents sometimes exhibited an insensitivity and lack of comprehension when dealing with their offspring that today appears quite shocking. This also applied to their servants, no doubt for the same reason, yet the latter often showed towards their employers an affection and loyalty which to us is as touching as it is sometimes unaccountable. It probably arose from the fact that although in one sense living in a different world, they nevertheless felt themselves to be part of the family. They had undefined rights but strictly defined duties, and whether their lot was a happy one or not depended on the family for whom they worked. It was an association which, particularly in country districts, often lasted from the cradle to the grave.

In spite of their strictness Mary and William's servants were very attached to their employers. Ethel remembered several of those at Richmond. First and foremost there was Nanny, with her formidable old mother, Mrs. Prosser, who came to help with the children when there was illness in the house or when, for some other reason, assistance was required. She had been Nanny to the Beresford family and was forever telling the Wells children how saintlike the Beresford children had been. If Ethel or Frank was naughty, she would put her spectacles on the end of her nose and look at them over the top. Alarmed and suspicious of what this might portend, it was all that was needed to restore good behaviour. There was also Richards, the house parlour maid, Mrs. Pearce, the cook, and several more indoor servants. In the stables there were strappers and a coachman whose duties were supervised by old West, now retired. He had been coachman to William's father and had come with them to Richmond. Every morning William drove in a carriage and pair to his office in the city. One winter morning old West went out of the stables and stood in the cold watching William come out of the house, get into the carriage and drive away. He stared after it until it was out of sight, then went back into the stables, where one of the grooms asked why he had gone out and if something was wrong. "No," replied the old man, "but I shan't see Master Willie again." During the day he had a stroke and had died before William returned in the evening.

CHAPTER FOUR

Suddenly, while Ethel was still a child, 'the crash', as it was always called afterwards, finally came and William Wells finally went bankrupt. It had, in fact, been coming for some time. Harry and Willie had to leave Harrow and become office boys and Cissie and Fanny left finishing schools in France and Germany to become governesses. Philip and Gerald and later Ethel and Frank were sent to stay for long periods with relations, who were indeed very good to them and did their best to help. The house in Richmond was sold, together with everything it contained, as also was Mary's jewellery and, what she minded most, the horses. The servants all had to leave. Nanny, who wished to remain without receiving any wages, was at last persuaded to go and live with her brother. Mrs. Pearce, the cook, continued for many years to send them hampers at Christmas, which no doubt the poor old thing could ill afford, but which were gratefully accepted by a family which now occasionally went hungry. Ethel and Frank felt the change of circumstances least, for the anxieties and difficulties of their elders passed them by. They only noticed that their mother, who never complained, looked tired and pale and became more silent as the days went by. Indeed she was the one on whom the consequences of 'the crash' fell hardest. Not only did she, who had never done any domestic work in her life, find it all inexpressibly vexatious and difficult, she also found William almost impossible to live with. He was always, in his way, a loving husband, but the disgrace of bankruptcy and the inability to provide properly for his family (which was in itself a disgrace in those days) preyed upon his mind. He worked desperately hard at any office job which came his way, arriving home in the evening tired, depressed and irritable. He would lose his temper with the older ones and occasionally strike them. Ethel remembered how once she

woke to see her father standing at the foot of the bed in his nightshirt, staring at the children, a candle in one hand and a revolver in the other. Mary told her that if this ever happened again to lie very still and pretend to be asleep.

All, however, was not gloom and despair. The four elder ones faced life with courage, determined to wrest from it every ounce of enjoyment possible. At this time they all lived at home and were able in the evening to recount to each other, with laughter and teasing, anything interesting or amusing which had occurred that day.

Frank's health was always an anxiety and occasionally kind relations would pay for him and Ethel to stay at some farm in the country. Once, when staying at a farm in Gloucestershire at haymaking time, a local witch who had been forbidden to gather wood in a certain copse, put a spell on the horses so that they would not pull the wagons. "Nothing would make them move, either backwards or forwards," Ethel related afterwards, "until the farmer relented and presumably the spell was removed." This incident so impressed the children that they never forgot it.

When Ethel was about fourteen she was sent to stay with some Edwards relations in Liverpool who were distantly connected both to her and to Lionel. She had practically no schooling, partly because the family constantly moved from one set of lodgings to another, and partly because her mother would not send her to one of the 'National Schools'—'Board Schools' as she called them—although any other type of school was financially out of the question. When Ethel arrived at Ullet Grange, in Liverpool, 'Uncle Edwards', as she always called him, immediately sent her to a local and excellent High School for Girls, but she was so backward that she was really unable to profit from its education. The only thing which she could always do beautifully was to read and recite poetry, which she loved.

There was also another factor which militated against her education and that was her affection for, and desire to please, 'Aunt Edwards' whose kindness to her she fully appreciated.

Uncle Edwards, through hard work and straight dealing as a cotton broker, had become wealthy, but his tastes had remained simple. His chief pleasure was to go down to Liverpool Docks with Ethel (since his own children refused to accompany him) and watch the arrival and departure of the great ships and the unloading of their cargoes. His other interest was reading and every evening he would retire to his

study with an unopened bottle of port and a book, and remain there until the former, at any rate, was finished, going to bed long after midnight. He knew nothing of the childrens' lives, for they were afraid of him and went to their mother for everything. The three pretty daughters, all older than Ethel, but very fond of her, spent their money on clothes and on entertaining. Their two brothers, Arthur and Joe, also spent their money on having a good time, working as little as possible. They were both in their father's business and Arthur was a brilliant business man, or would have been had he not also been an alcoholic. Unfortunately, to complete his down fall, he not only married another alcoholic, but adopted a dwarf, named Levine whom he had rescued from the slums of Liverpool and who became his evil genius. As Arthur and his wife Madge became more and more incapable of managing their own affairs Levine took charge. He spent their money, encouraged them to drink, filled the house with bad companions and when Madge died of tuberculosis and Arthur had become a frequent sufferer from delirium tremens was, incredibly, allowed to become Arthur's keeper. Things had reached such a pitch that Uncle Edwards had forbidden any of the female members of his family to visit Arthur's house, which was only a few miles away, under any pretext. Aunt Edwards, however, anxious about her elder son, hit on a plan to find out about his well-being. She asked Ethel to visit Arthur once a week instead of going to school. So once a week Ethel, carrying a basket of dainties, and going by bus since the carriage could not be used without the servants' knowledge of events, would set out alone after waiting until Uncle Edwards had gone to the office. She returned before he came home. Arthur, confined to his bed now, was always pleased to see her, but in his sober moments told her not to come again because of Levine. Ethel hated Levine and he knew it, but never attempted to harm her. Once when she went into Arthur's room he asked for a drink from a glass of water beside him. Ethel found he could not reach it himself because he was strapped tightly to the bed, owing, he said sadly, to the fact that he had been violent the previous evening, so that Levin and his friends had had to restrain him.

When the end of term came and Uncle Edwards received Ethel's school report he was astonished to learn that her progress might have been more rapid if she had not played truant regularly for a whole day once a week. He questioned Ethel for a long time, but she maintained what must have seemed a sullen silence. What could she say that would

not incriminate Aunt Edwards? Poor Ethel longed for the latter to own up, but she never did, apparently too afraid of the old man to do so. Ethel had became very fond of him and was made wretched by the desire not to seem ungrateful to either of them. So she remained miserably silent.

Every summer the entire Edwards family, servants and all, went to their country house in Wales, often taking Ethel with them. It was not far from Benarth but the latter was always let at this time of year and Lionel and Ethel never met. On one occasion Ethel saw what came to be known to the family as 'her' ghost, although it was seen afterwards by several others. She was about fifteen at the time, and was accustomed to stay up for dinner, but when the dessert was brought in, to take some of the fruit and go up to bed. One evening, crossing the bedroom to put the fruit on the dressing table, she turned back to shut the door. When she reached it she saw confronting her, crouched against the opposite wall, a woman with long brown hair, in a striped dress and with wide terrified eyes. They stared at each other for a few seconds, then Ethel, suddenly feeling that the woman was going to spring at her, turned and locked the door. When, later on, her cousin Annie, who shared the room with her, came up to bed, she was surprised to find the door locked, and on hearing the reason a thorough search was made. The woman 'had got in' somehow and would doubtless steal anything she could lay hands on. No one was found and nothing was missing, but when a few days later a groom reported that 'that woman' had followed him to the stables and then disappeared, the police were informed. The woman was seen several times, and each time a search was made until one afternoon some weeks later, the news having had time to travel by then, a strange woman came and asked to see Aunt Edwards. She said she had walked twelve miles across mountains from the parish where her husband was now the vicar, to tell them about their visitor and her appearances. When her husband had been vicar of the parish, he had learned all about her. Thirty years previously the house had been a farmhouse, and one night the farmer in a drunken rage, had murdered his young wife. It was her ghost they had seen, but there was no need to worry for she would do them no harm.

Aunt Edwards gave the vicar's wife a large tea, and after thanking her for the trouble she had taken to reassure them, sent her home in the carriage. Many of the Welsh clergy were at that time desperately poor

and Ethel with a fellow feeling, never forgot the vicar's wife, with her gaunt features, heavy farm boots and wearing a conglomeration of unsuitable clothes which people had given her.

As for the ghost she was still seen occasionally, but now no one minded and, except by Ethel, the incidents were gradually forgotten.

CHAPTER FIVE

Lionel's adolescence was, compared with Ethel's, uneventful. He and his mother continued to spend their time either in lodgings or with friends and relatives. He had no companions of his own age, so did not play games and never during the whole of his life played in a team-game. He was entirely dependent on himself and on adults for his amusements, but never appears to have felt lonely or unhappy. He enjoyed most being taken to the theatre or to watch Fitz play polo at Ranelagh. Polo was one game he would have liked to play himself.

On one occasion he was taken by a cousin Ethel Peters (later Lady Preston) to the Summer Exhibition at Burlingon House. She used to recount afterwards how Lionel, a tall, thin, awkward schoolboy, his long red hands and bony wrists protruding from the arms of a coat he had long outgrown, solemnly marked on his catalogue those pictures he thought worthy of his approbation, at the same time explaining to her in an embarassingly clear boyish voice why some were, in his opinion, so bad that they should not have been hung at all! She did not stop him for, as she said with some amusement, he did not mean to be arrogant or rude, but was merely stating what he considered to be facts.

When Lionel was older, being intended for the army, he was sent to a crammer, but though in theory very interested in military matters, in practice he showed no inclination to be a soldier. Finally his mother acceded to his request that he should be allowed to attend an Art School.* He said of himself, "My student days, according to students who were my contemporaries were not of arduous toil. I must have done some work however and quite definitely I owe no small debt of gratitude to Frank Calderon, who at that time had a School of Animal Painting in Baker Street and to Dr. Armstead, his anatomical lecturer.

*Reminiscences of a Sporting Artist.

Being hard up, it was lucky I won a scholarship or two, which seemed great events at the time."

Lionel's artistic education was now and again interrupted by sporadic visits to Benarth, sometimes for months at a time if it was not let. He enjoyed these visits, although Harriet did not, but neither of them really appreciated the old house and its lovely surroundings.

Benarth, when Dr. Edwards bought it, was a small estate the fields and woods of which ran down to the River Conway. The estate extended as far as Tal-y-Cafn is one direction and on the hills above Conway included the village of Gyffin in the churchyard of which Dr. Edwards is buried. From the woods above the drive was a well-known view of Conway Castle, commemorated on plates known as 'Benarth Plates' which were made just after Telford's suspension bridge was completed in 1826. One is still in the possession of the family. The drive led from just outside the town up through the woods to where the old house stood high above the river, looking out over terraced gardens to the mountains beyond.

The house had had many owners and had been altered many times. The oldest part was the drawing room, reported to be haunted by the ghost of a laundry maid stabbed to death there by her soldier lover. It was said that the stain of her blood on the wall came through every wallpaper and certainly there was a mark there which was always hidden by Harriet by a piece of furniture. Under the drawing-room was a large cellar-like room with windows from which one could just see the feet of anyone walking in the garden outside. The room contained three lavatory seats, one large, one medium and one small. They were very old, and Lionel, as a little boy, and Derrick and I later on, were forbidden ever to climb on them in case they gave way and precipitated the climber into an abyss of tanks and tunnels below.

Beyond the drawing-room and built one would suppose at a later date than the rest of the house, was a circular music room, with a domed glass roof, high walls and beautiful mahogany doors which, in our time, refused to be opened from the inside, so that it was possible for an unlucky inmate to be incarcerated there until released from the other side. The builder of this room, the then owner of Benarth and a bachelor, installed in the room an organ which he would play for hours at a time. One evening, so it is said, he told the servants he would be going out to dinner and would not be back until late. They were surprised, therefore, to hear the organ playing early in the evening. On

going to the room, they found no one there. The following morning
they heard that the carriage in which their master had been travelling
had been blown over the cliffs near the Great Orme's Head. Harriet
claimed to have heard the organ several times as had others. There was
another haunted room called the French room, a bedroom in which
neither Ethel nor Lionel really cared to sleep. Harriet, however was a
Scot, to whom ghostly happenings were not to be feared but accepted as
natural and a part of life.

My own memories of Benarth are clear and definite as childhood
memories are when those of more recent happenings are forgotten. One
recalls scenes with a sort of clear brilliance and always it seems the sun
was shining. Our day nursery was the same room as Lionel had as a
child, of which, long years later he said, "My nursery window looked
across a mile of river estuary, which became mudflats and sandbanks at
low water, haunted by duck and waterfowl whose plaintive cries became
woven into my childish dreams. Even today the cries of the oyster
catcher, the curlew or the little dotterels and sandpipers make the years
fall away and for fleeting seconds I am a child again."

Behind the house, on the other side of the drive were the stables and
the kennels, the latter built by Dr. Edwards. When too old to continue
foxhunting with the Warwickshire, he gave it up altogether and hunted
a pack of beagles from pony back in the Welsh hills.

In 1931 it occurred to Lionel to write to his old half-sister, Mary
('Tottie') Peters, to ask what she remembered of the Benarth beagles.
He received this letter in reply:

> Dear Nello,
> Wrong about the beagles being sold to Lord Mostyn.
> They were sold to Sir Vincent Corbett, Action Renald, (I
> forget how it is spelt), and when staying at Shawbury
> Vicarage with Uncle George, Sir Vincent asked me to go
> over to see my old pets, in his keeping then, but I do not
> know what happened to them after that. *We* never had
> meets—quite private hunts tho' sometimes we took them
> over to Sir Rees Mostyn. They were beagles (not rabbit
> beagles). That's all I can tell you, but we used to have jolly
> runs on the mountain sides and down the Sychnant Pass.
> I have been feeling seedy, but am better now. I'm not fit
> for much these days—feeling at last how old I am—88.

By the way, remember I was only thirteen or fourteen when we had the beagles. It's a long way back. I never remember hearing of anyone else having beagles near us in those days.

Your affectionate old sister,

Tottie Peters.

During the two years preceding the 1914 war, Lionel kept bloodhounds in the old kennels and hunted as his father had done, across neighbours' properties when allowed to do so, and on the mountain sides and hills near Benarth. He rode to hounds, which hunted the clean boot. The quarry was usually Ethel or Fred the gardener.

When Lionel was about twenty an event occurred which was to have the greatest significance in his life—Ethel came to stay at Benarth.

Circumstances in the Wells family had become more and more difficult as they went through a series of crises the memory of which remained with each of them for the rest of their lives. First, there was Hugh. Very early one morning, answering a knock at the door, Cissie found a small boy standing on the doorstep, who said that the priest had sent him. It transpired that George, William's elder brother, having contracted in Spain an illness from which he realised he was dying, had returned to England, leaving his mistress behind, but bringing with him his illegitimate little son. Having become a Roman Catholic, in the last stages of his illness he sent for a priest to give him the last rites, at the same time asking the latter, after his death, to send the child to the address given and ask his brother William to take him in. This William did without a moments hesitation, and Hugh became a member of the family—and one more mouth to feed.

Next, later on, there was Harry. Cissie and Fanny had by this time obtained posts as governesses and left home. Harry, having no opportunity for friendship with girls of his own class, had become attached to a girl who, though pretty and goodhearted was also uneducated with tastes and outlook totally dissimilar from his. When she became pregnant by him, Harry went to his old headmaster at Harrow, Dr. Welldon, and asked, "Ought I to marry her?"

"Of course," was the reply.

Harry had two sons by her, but the marriage was a disaster, and while the boys were still very young he decided to accept an offer of work on a tea plantation in Assam. From there he would send money home and also, he hoped, be able to save enough to send the boys later on to school in Germany and afterwards perhaps to Heidelburg University.

Ethel remained at home to look after the family. Frank had contracted tuberculosis and was in and out of a sanatorium according to the ability of various members of the family to spare enough money to keep him there. Everyone contributed if he or she could, and when money ran out Frank came home. During a bout of illness in one of these periods he was attended by a young Spanish doctor named Paul, who quickly became a close friend of the family. He had just returned from one of the many wars in South America where he had practised as a doctor, using the hypnotic powers he possessed to anaesthetise the wounded before operations. Paul fell in love with Ethel and she with him and or a few months they went about together and were extremely happy. Then, one day when Paul called at the house, he was met at the door by the brothers.

"We have been told," they said "that you are married already and that your wife is living in South America. Is this true?" Paul replied that it was, but that they had been separated for years. Since, however, they were Roman Catholics, there was no question of a divorce. Paul agreed that he must never see Ethel again. He went away and they never did meet again.

Ethel, just seventeen and very much in love, was hurt and angry with both Paul and her brothers. She became silent and difficult, and seemed unable to interest herself in anything. The family worried about her, and when Fanny, who at that time was acting as companion to Lady Maine, reported that Mrs. Harriet Edwards, Lady Maine's half-sister, was looking for a companion to return with her to Wales, Ethel was persuaded to go, much against her will.

From poor Harriet's point of view the visit was not a success. Ethel, shy and badly dressed, hated the afternoon calls on neighbours which were then the fashion and in which Harriet delighted and expected Ethel to accompany her. The two had nothing in common, and whilst recognising how kind and well-meaning Harriet was, Ethel, a country lover, could not understand why she should so dislike Benarth and long for London. Nor could Ethel understand why Harriet should so spoil 'Nello'. Lionel at this time was in the worst stage of adolescence. He knew everything, was arrogant, selfish, inclined to bully, fretful and sulky if he was frustrated in any way, and showed none of the consideration for a feminine companion which Ethel had come to expect from her brothers and their friends. He thought her spoilt and conceited, and disliked her quick-wittedness, especially her sharp

tongue, the thrusts of which he was quite unable to parry. He therefore enjoyed nothing so much as being able, as he put it, "to take her down a peg". As they were inevitably thrown a great deal together, the opportunities for quarrelling were endless. Ethel came from a family of animal lovers, Lionel only considered them as objects of interest, either as a naturalist, as Arthur had taught him, or for sport. He would set his dogs on cats, put rats from traps into a loose box in the stables, for his terriers to kill and, Ethel felt, was not quick enough to kill a bird or rabbit he had wounded when shooting. So she shooed away the cats before he got there, let out the rats while he had gone to fetch the terriers and refused to go shooting with him. When the two played cards with Harriet, all was peaceable, but when they played chess Ethel won every time and when Lionel saw that defeat was inevitable, he would refuse to play any longer and stump off angrily to bed. Ethel was amused, but not so Harriet, who was once unwise enough to ask her if she could not sometimes let Lionel win. "Of course," replied Ethel scornfully, and next time allowed him such an easy victory that he announced furiously that he would never play with her again.

In the summer, when the fruit in the old walled garden was at its best, they would play a childish game. After lunch on Sunday they would race each other to the kitchen garden to eat the ripest peach before the other arrived. One Sunday when Ethel had been the successful one, Lionel was so annoyed that he picked her up and put her in the large, swinging water carrier. There was no water in it, but as it tilted backwards and forwards at the slightest movement, Ethel was obliged to stay there until the young under gardener, Fred, came in the evening to do the watering. "Well indeed," he said, as he lifted her out, "that was not nice of Master Nello."

There was one thing however, for the enjoyment of which Ethel would put up with any of Lionel's tiresome ways. Lionel used to ride the old carriage horse, Blackie, and one day, realising how much she loved horses, and how envious she was, offered to teach her to ride. An old lady, who was at that time in her nineties, provided Ethel with a voluminous riding habit which she said she had worn when a girl. She also gave Ethel an extraordinary old side-saddle which she said had belonged to her mother and so was well over a hundred years old. It was altered by the local blacksmith to fit Blackie, who, though strongly disapproving of such a contraption, finally allowed Ethel to ride him. He was blind in one eye and used this as an excuse to shy often

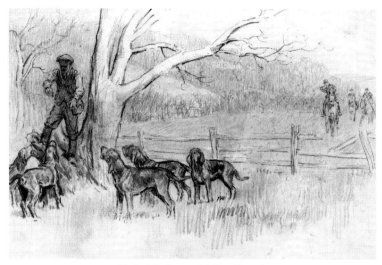

End of the hunt with bloodhounds.

and unnecessarily, after which he would buck. When he had dislodged
Ethel he would return to the stables, leaving her to make her way back
in a garment which was certainly not designed for walking.

One day she and Lionel took Blackie to a piece of rocky common
behind the house known as the Sheepwalk. Ethel had scarcely mounted
when Blackie gave a violent buck which threw her off. She landed on
the back of her head on a rock. She said afterwards that on regaining
consciousness she found herself being dragged by the heels, on her
back, over bumpy ground and hearing Lionel's frightened voice saying,
"Are you all right, old girl, we'll be home in a minute." Ethel was quick
to reassure him that she had recovered.

When winter came, a hard one with snow and ice, they stayed on at
Benarth and Lionel discovered a new pleasure. He had a sledge made,
and pulled by Blackie. He and Ethel would go down the drive and
across to the suspension bridge at Conway Castle. There they would
cross and recross the river to annoy the grumpy old toll-keeper, who
was unable to charge them a toll as their conveyance had no wheels.

The relationship between Ethel and Lionel had by then become more
amicable and the sledge ride was in later years recalled by both with
amusement and pleasure.

In 1944 Lionel wrote an article about it for *Country Life*, in which he says: "We made a home made sledge out of a garden seat, with two ash poles as shafts. It was terribly heavy and I cannot remember now how we made stops on the shafts or to what we attached the breeching. I suspect that string must have been much in evidence. The pony was 14.2. He had only one eye and a funny temper, yet most gallantly did he pull the cumbersome vehicle to which he was so precariously attached. The only passenger who would risk travel in this strange contrapton was a bright-eyed Victorian miss in fur cap and red many-buttoned jacket which tightly embraced her somewhat ample charms, who today as a little white-haired old lady still retains in spite of the snows of many winters, her sense of humour and the same spirit of adventure and mischief."

The time came when Ethel had to go back to London, Frank having returned home from the sanatorium because, once again, there was no money to keep him there, and Ethel being required to look after him. She was sorry to leave Benarth, which she had come to love, but delighted to be returning to her family.

Lionel quickly realised how much he had come to depend on her companionship and persuaded his mother to let Benarth again, as soon as possible, and obtain lodgings in London, on the grounds that it was extremely difficult to work for the Press (which he had now begun to do) from Wales. This was true and it says a great deal for the postal service of the times that he was able to do so at all.

He did not tell his mother that in London he would sometimes be able to meet Ethel.

The latter had returned to a home where money had become so short as to be at times almost non-existent, with the result that, since rent could not always be paid, there was a constant exodus from one set of lodgings to another, each time into a cheaper or nastier version in a less desirable neighbourhood. On one occasion in lodgings in which the family did not remain a moment longer than was necessary, Cissie, who was home at the time, shared a room with Ethel at the front of the house. One night, after midnight, they were awakened by the sound of horses in the street below. Peering through the curtains they saw a cab draw up in front of the door, and shortly afterwards the owner of the lodgings and his wife appeared, carrying a young girl seemingly either dead or unconscious. They put her in the cab, which then drove off. The following morning Cissie said cautiously to the landlord, "We thought we heard sounds during the night. Was anyone taken ill? Did anyone have to be taken to hospital?" "No one was taken ill in the night," replied the landlord, staring straight at her. "There is no one else in the house except your family, my wife and myself."

The white slave traffic was then at its height, but as Ethel said afterwards, "We wondered, but in those days, if one was really poor, one could not afford to get involved in anything—and anyway we had no proof."

When enough money had been scraped together Frank returned to the sanatorium and Ethel felt that she should now find some kind of employment. She took a post as a nursery governess to a Jewish family living inthe country just outside London. When being interviewed, Mrs. L., rich and beautiful asked, "And what kind of clothes do you usually wear?"

"Much the same as other people, I suppose." answered Ethel sturdily, and then catching a gleam of amusement in her future employer's eye, realised that this was just what she was not wearing, since her clothes were a motley collection of borrowed garments, none of which fitted her properly. However. nothing was said and Ethel duly became nursery governess to the two little girls, cycling seven or eight miles to and from work every morning and evening. Her duties were not arduous and consisted of taking over from Nanny in the morning, teaching the elder one for a short time, taking them for a walk in the afternoon and then returning them to the nursery and Nanny.

The son of the house, a spoilt and dissolute only son of very rich parents, was attracted by Ethel, who was indeed very pretty. She had masses of dark hair, long enough for her to be able to sit on it, hazel eyes with a mischievous twinkle, and very long eyelashes. She also had a beautiful complexion, which she never lost, and a neat and very good figure, having no longer the 'somewhat ample charms' described by Lionel.

Nanny warned Ethel never to go out with young Mr. L. on his motor cycle, but he could not be prevented from lending her books and spending much time in the nursery discussing them with her. He suggested one morning that she should go down to the library and choose a book for herself. Having seen her safely inside, he slammed the door shut, saying triumphantly, "Now I've got you." Ethel moved to the bell, saying, "If you come nearer, I shall ring."

"And who will believe anything you say?" he sneered, "just the little governess?"

"My brothers," replied Ethel quietly, "I have told you what good boxers they are. Do you wish them to prove it?" After a moment or two

he opened the door and let her go. Shortly afterwards she made some excuse to give Mrs. L. notice and left her employment.

Cissie now obtained a post as governess in Paris, Fanny was companion to Lady Maine, and as it was necessary for one of the girls to be at home, their mother having become very frail, Ethel once again stayed to look after the family.

She met Lionel fairly frequently, as at this time he and his mother were staying at Cornwall Gardens. After Sir Henry died Lady Maine was lonely and enjoyed having her half-sister Harriet to help her entertain her many friends. She also loved young people and gave dinner parties for Charles, her elder son, and for Lionel. Her second son, Harry, was unfortunately a mental defective, but he was never left out of any festivity and attended every dinner party of his mother's, however distinguished the other guests. He was very fond of Lionel, whose teasing, as far as he was concerned, was always kindly.

Lionel soon became acquainted with all the members of the Wells family, but although he enjoyed being with her, his relationship with Ethel at this time seems to have been entirely platonic. Indeed, at some time during this period he became engaged to a relative, Alice Dickinson, but though his mother encouraged the engagement, their characters and interest were too dissimilar and it was soon broken off.

Although in some ways Lionel disliked town life as much as Ethel did, he found various happenings both exciting and enjoyable. For one thing he was now able to do a great deal of work, and though it is doubtless true, as he said in after life that he "turned out some dreadful trash," he also said that this period, working almost entirely for the Press, was an invaluable experience in that "it requires both speed and quick decision to sketch contemporary events—race meetings, etc." Many people in later years marvelled at the speed and dexterity with which he executed drawings or water colour sketches.

At one time he cycled every morning from his aunt's house in Cornwall Gardens to his first studio in Holland Street, lent him by a cousin, Katie Halkett. From the back door of this studio he bought his first pony, for £15, from a job master who, for reasons of his own, wished to dispose of it immediately. Lionel collected at break of day a well-bred, one-eyed pony, which he kept for a time in his aunt's stables, unknown to her, until, as he said,* "I had to own up eventually when

*Reminiscences of a Sporting Artist.

the coachman was asked awkward questions about the sudden increase in his fodder bills.'' The pony was a success and Lionel would ride to Richmond by comparatively country lanes to visit his half-sister Mary ('Tottie') Peters, returning by Wimbledon Common.

"Once," he says, "we ventured to a meet of hounds at Esher, which is a long hack from Kensington. I imagine the late Cecil Aldin was the last person to hack to a meet from Bedford Park, but I should think no one has since tried to emulate either of us.''

Unfortunately keeping a horse in London proved too expensive, and Lionel had once again to be content with his bicycle. Most week-ends he cycled out of London into the country, sometimes to meets of hounds, and when she could get away Ethel accompanied him.

While still a student Lionel was elected to the London Sketch Club where, outside the R.A. circle, he met most of the well-known artists of the day. These included Cecil Aldin, Phil May, John Hassall, Tom Browne, Lance Thackeray and George Haite, who was president.

Lionel greatly admired Phil May, both as a man and an artist, and says of him in *Reminiscences of a Sporting Artist*: "Phil May made a lot of money which he gave away faster than he could collect, he being the most generous person of whom no one ever asked in vain." Phil May was a brilliant draughtsman and a most interesting character. He had a studio in Holland Road and there is a story, probably untrue, that every morning he went across to the Holland Arms for a refresher. One day, being in want of a policeman for a model, he asked the constable on the beat if, when he came off duty, he would come and sit for him. After a drink or two, on his way home, Phil met another policeman, of whom he asked the same thing. Diverted into a friend's studio for another drink, Phil started for home again, remembering only that he wanted a policeman as a model. Meeting another, Phil asked him too, and so it went on. By the time he reached his own studio there was quite a posse of police outside. "Good God," said Phil, "what's wrong, a fire or something?"

Lionel's greatest friend at the Sketch Club was Lance Thackery, and one summer both went to Benarth for a painting holiday. All went well until one morning according to Lionel 'Thack' appeared very white and silent and announced that he had had a telegram and must return to London immediately. Later he admitted to Lionel that there had been no wire, but could not be persuaded to say what had happened to cause this sudden flight. Lionel, however, knowing that Thackerary had slept

in the haunted 'French' room, suspected that perhaps he had felt the same icy hand on his face which once, when Lionel was about fifteen had awakened him, so that with a yell of terror, he had fled into his mother's room, spending the rest of the night on a sofa. Harriet, with one of her occasional lapses into broad Scots, had merely remarked "Hoots, mon, dinna fash yersel' o'er a wee ghostie."

When Ethel stayed at Benarth she also slept in the French room. She felt no icy hand, but the huge mahogany door would sometimes burst open, even on a still night. Ethel never locked it, for, she said, "If I had locked it and then it had burst open, I should have been terrified."

CHAPTER EIGHT

"In 1902," Lionel used to say, "two very important events occurred—I had my first real stag hunting and I got engaged to Ethel." It was often pointed out to him that he should reverse the order of events.

The engagement took place when Ethel told him she had taken a post in Ireland. Alarmed, anxious and annoyed and realising that he had fallen in love, Lionel proposed and was accepted. Both sets of parents were furious and refused permission to marry, Harriet because she thought Lionel, with many fashionable friends whom he met at the Maines, should do better than marry the penniless daughter of a bankrupt, and William Wells because he thought his daughter should do better than marry the impecunious youngest son of the owner of an impoverished estate, with no means of supporting a wife except by his dubious artistic talents. Both young people, their determination strengthened by opposition, refused to break off their engagement, but for the moment marriage was out of the question.

Ethel went to Ireland to look after the small daughter of a Frenchman, Henri Perraud and his Irish wife. Henri had been sent by his father to Ireland to learn to be a racehorse trainer, and had been 'trapped', according to Ethel, into marrying the trainer's pretty daughter. The marriage was not a success, although Henri did his best to make it so, and was very fond of the little girl, Kiki.

One day a letter came from his father asking Henri to bring his wife and daughter to stay with him in France. As his father was old and very anxious to see his grandchild, Henri decided to go, but his wife flatly refused, saying that as she was going to have another baby and was not well, she did not wish to make the Channel crossing, so it was arranged that Henri, Ethel and Kiki should go. Ethel was delighted at the prospect and in fact enjoyed it all immensely.

The estate was in a lovely part of France, the chateau a beautiful

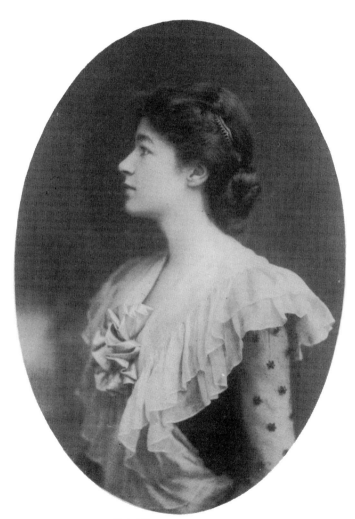

Ethel Edwards aged eighteen.

house and the Marquis a dear old man, courteous and kindly. Ethel seems never to have troubled to learn French, finding this did not matter as most of Henri's young friends spoke English.

Henri did his best to make her stay in France enjoyable by letting Kiki sometimes stay with her grandmother, which enabled Ethel to go about with him and meet his friends. As she was very attractive, the young men made a great fuss of 'the English miss'. One day, one of them told her he had been invited to a river picnic and asked if she would like to accompany him. Ethel accepted, with alacrity, and went to ask Henri if she might have the afternoon off. On hearing about it, Henri was furious, and said, "Certainly not. This is not for you."

Ethel, very angry, said, "Just because they have not invited you, why should not I go?"

"I will not have it," replied Henri. "He should not have invited you."

"Tell me why," said Ethel, "or I shall go anyway."

"If you wish, then," answered Henri. "The girls these young men are taking are all prostitutes. Do you wish to join them?"

A very startled Ethel decided that discretion was the better part of valour and did not go. She was unwise enough, however, in her next letter to Lionel, to tell him all about it. Forthwith she received a telegram saying, "Return at once, or it's all off." Ethel promptly replied, "It's all off."

In due course Ethel returned, first to Ireland, then to England, where she was once again needed at home. Lionel, full of the delights of his holiday and the joys of stag hunting apparently forgot about the telegrams and all was well.

Lionel had gone to Porlock with Fitz, who was on leave, and taking two horses with them, hunted and hacked on the moor until Lionel learned to know every hill and combe and to love this country more than anywhere else in England. Throughout his life he went down to Exmoor at least once a year, more often if he could manage it, to hunt with the Devon and Somerset Staghounds. According to *Reminiscences of a Sporting Artist*, "The Master of the Devon and Somerset Staghounds at that time was a Mr. Sanders (later Lord Bayford) and the huntsman, Sydney Tucker. The chase was not so fast as it became under his whipper-in Ernest Bawdon who succeeded him as huntsman. The big dog hounds and cock-tailed cobs then in use could not compete with their present day successors. If the chase was slower, it was to me far more interesting, for, given time to employ his natural cunning,

the stag has more than a fair chance of defeating pursuit. Lord Ribblesdale's axio, 'A deer must not be hunted as you hunt a fox,' was actually said of a carted deer, but I have always felt that it is also correct in respect of the wild animal.''

Lionel did his first stag hunting picture of a kill at Horner Mill, and finding a ready sale for it, held his first exhibition in the parish room at Porlock. He sold all the pictures, at no doubt very modest prices, but with great satisfaction, since they paid for his hunting holiday.

To quote again from *Reminiscences of a Sporting Artist*, Lionel says, "The first stag I ever saw killed was at New Mills, Buxborough, in a cottage garden. It was a pictorial scene, with the obvious title of 'Death among the Flowers'. Although I was a beginner in Art, it struck me at the time that this was not the sort of hunting subject that would appeal to British sportsmen. That celebrated painter of the Flemish school, Franz Snyder (1579-1657) painted hunting pictures which were intensely dramatic, with a foreground of injured hounds round a furious boar or stag at bay. One sees a few examples of his work in this country, but his view of the chase was distinctly Continental and very German at that—a country where the chase was more of a battle than a hunt. This has never been, since Tudor times (when it prevailed here also), the attitude of the British to sport. If you study the work of the more celebrated English sporting painters, you will notice few pictures of this kind. It is true Stubb's 'Grosvenor Hunt' (his best picture) depicts a stag at bay, and Landseer, always in search of the theatrical, did the same, but Ben Marshall, R. B. Davis, Abraham Cooper, Alken, Ferneley, Herring and subsequent painters of sporting subjects, all depicted the human element as their subject, or else horse and hound—the quarry being merely an accessory. The stressing of the death of the hunted animal is foreign to the ideas of English sportsmen.''

Lionel himself rarely depicted the actual kill of either fox or stag unless the picture was a commission, and he was especially asked to do so. It must be inexplicable to some that, like many other English sportsmen, he loved both animals, although never missing an opportunity of hunting either.

In the autumn of 1902 Lionel and Harriet returned to Benarth, where they remained more or less continuously for the next two years. Harriet, while wishing herself elsewhere, was nevertheless glad of the opportunity of separating Lionel and Ethel. But 'absence makes the

heart grow fonder' and Lionel found he frequently needed to go to London to obtain paper or painting materials from Messrs. Reeves, or to watch Fitz play polo at Ranelagh when he was on leave, or to go to the Sketch Club, any one of which could provide an occasion for seeing Ethel.

He sometimes visited the little house at Crouch End where the Wells family now found themselves, and became better acquainted with Frank, whom he learnt to admire greatly for his courage and cheerfulness. In fact, Lionel, always generous and open-hearted, contributed whenever he could, out of his small earnings, towards Frank's residence in the sanatorium. At some time, during this period, Harry, Ethel's eldest brother, returned from Assam where he had contracted that dreaded disease Kala-azar.

When he realised he was dying, he managed to make his way to Calcutta, where his old headmaster, Dr. Welldon, was then bishop, and asked him to help him to return to England. Harry said he wished for only two things, to see his parents again, and to die in England.

Thanks to the kindness and strenuous efforts of the bishop on his behalf, Harry's wishes were granted. He returned to England and his parents' home, where he died a few months later. After his death his two sons, Henry and Leo, came to live with their grandparents.

When it became evident that Frank, who had been at home, ought to return yet again to the sanatorium if his health was to improve, Ethel once more found it necessary to take a job.

In these days, when all classes of society are so intermingled that knowledge of each other's circumstances is inevitable, there is also a much greater understanding of and sympathy for those who suffer from poverty, ignorance or inadequacy, than prevailed at the end of the last century and the commencement of this one. With notable exceptions, the Victorians and Edwardians were adept at pretending that what they did not wish to see did not exist. This particularly applied to men with regard to their wives and daughters. From the Queen to the humblest of her subjects who might claim to be 'a lady', they were prevented by their menfolk from knowing about anything which might spoil their innocence or cause them unease. Thus homosexuality, prostitution or the 'White Slave Traffic' were almost unknown words in polite society, or, if they were known, never mentioned. Most young ladies therefore really were very innocent and ignorant. Thus some incidents in Ethel's life which now seem of slight significance, were of importance in that

they influenced permanently her attitude towards the effects of poverty and environment. She never forgot the people concerned and would never afterwards condemn those whose behaviour she felt might be the result of circumstances over which they had no control.

Ethel became a waitress in a would-be select restaurant in the West End, the staff of which were supposed to consist of 'ladies' only. This was mainly true, but in fact it was also a glorified brothel. Its owners, a Mr. G. and Miss M. were expert at finding pretty girls whose circumstances, due to poverty and lack of education, caused them to be unable to find other employment. Ethel was fortunate in making friends, almost at once, with a New Zealand girl named Trent. She was the cook, earned high wages, and was very well able to look after herself—and Ethel. They would wait for each other and go part of the way home together.

One evening, however, while Ethel was waiting for Trent, she was roundly abused by a woman whom she afterwards realised was a prostitute who thought Ethel had invaded her beat. On another occasion Ethel was so frightened by being accosted by a strange man that he had to catch her by the arm to prevent her diving into the traffic where she would be in imminent danger of being run over.

Ethel also made friends with two girls to think of whom afterwards always distressed her. One was a girl who had become a prostitute in order to provide for an invalid mother and also to help pay for the training of a young brother who wished to become a priest, but who, of course, had no knowledge of the way the money was obtained. The other was a very beautiful girl who had no relations and few friends. One day she told Ethel that a young man who had recently been coming regularly to the restaurant, had asked her to dine with him. She went off happily with him in a cab, but never returned, nor, in spite of police enquiries, was she ever seen again. It was presumed she was a victim of the white slave traffic.

The following summer Ethel left the restaurant. She had fainted several times in the hot, stuffy rooms during a heat wave, and Lionel persuaded her to stay at home until they could be married, although marriage at this time seemed as far away as ever.

Lionel himself, living half his time in London and half in Wales, had begun to work really hard. Some of his early work for reproduction, in flat washes and ink, and resembling that of Cecil Aldin, still exists and turns up from time to time. He also painted one or two pictures cast in

the heroic mould, inspired perhaps by those of Mr. Clarence Whaite, at that time president of the Royal Cambrian Academy, to which thanks to his influence, Lionel was elected at an early age. These pictures by Lionel were bought by art galleries and one, entitled 'The Lake Maiden' portraying a scene from one of the Welsh legends, was much admired at the time. To this period also must be ascribed a picture on the back of which is written "Original Drawings of the Bombay Foxhounds by Lionel Edwards A.R.C.A." It is perhaps worth recording that although several people have claimed to have met him there, Lionel never went to India in his life.

In 1904 Lionel went on a painting expedition in Oxfordshire with Harry Spence, an artist of the Glasgow School. He was a landscape painter of whom Lionel has said, "He had a marvellous eye for a subject and could show one, almost at first glance, several alternative compositions of the same scene—a rare accomplishment which I have myself since found most useful. I owe much to my previous teachers in the way of draughtsmanship, but he was the first person to make me use my eyes."

When not painting, Lionel went hunting, usually to meets of the South Oxfordshire which at that time had Walter Kyte as huntsman. He still depended on his bicycle and used to ride quite long distances. The disadvantage of this method of pursuing the fox was that at the end he was obliged to walk back to retrieve the cycle he had abandoned earlier in the day to follow across country. One hot morning, on the way back, he went to sleep in a ditch, and was awakened by a policeman, who thought he was a drunk.

CHAPTER NINE

While Lionel was beginning a career as an artist, his eldest brother Fitz was already making a name for himself as a soldier. He had joined the Poona Horse in 1885, and fighting on the North West Frontier in 1897-98 was mentioned in despatches and awarded the D.S.O. As part of the international force, sent to quell the Boxer rising, his regiment formed part of the Cavalry Brigade and Fitz, Now a captain, joined it from 'staff employ at Mhow'.* After the campaign, and by then a major, he was duly enrolled as an honorary member of the Order of the Dragon. Returning to India he later married Lily Stewart, a beautiful and intelligent girl but spoilt by all the attention she received. She had come to care only for the gay parties and entertainments which at that time filled the days of so many of the wives of the British officers. Fitz loved children and when his son was born he was delighted. The baby, however, was very delicate and when, on leave in one of the hill stations, Fitz had to retun to Delhi for the 1903 Durbar, he insisted that Lily and the baby should remain where they were and not accompany him on the long and difficult train journey. Lily could not bear the thought of missing the magnificent spectacle of the great review when Lord Curson would inspect the forty-thousand troops assembled for the Durbar, or of being unable to attend the celebrations which would follow. After Fitz had left she also returned to Delhi, accompanied by the baby and its amah. Shortly after their arrival the baby died, and Fitz, furious and heartbroken, with an implacability which his family had always recognised, never forgave his wife. Their marriage was at an end, although life went on as usual until, sometime in 1904, Fitz went away pigsticking. He was a noted expert, winning the Guzarat Cup in 1905. On this occasion he had a bad fall and broke his leg. He was taken

*The Poona Horse, Vol. 1, p. 154.

to the bungalow of a Major Dyson, whose wife Clare nursed him until he had recovered. Clare and Fitz fell in love and when Clare told him she was unhappy in her marriage he agreed to take her and her two small daughters back to England with him when next he went on leave. In 1905 Major Dyson obtained a divorce, citing Fitz as co-respondent, and Fitz, Clare and the two children came 'home', followed by Lily, who perhaps only now realised how much she really cared for her husband.

They all went to live with Harriet and Lionel at 5 Warwick Studios, Kensington. How this impossible situation came about one does not know, but it drove Lionel to distraction. His mother was greatly upset, being very fond of Lily, and Lionel himself, devoted to Fitz as he was, thoroughly disapproved of his conduct, knowing at the same time that the latter would brook no criticism.

Lionel spent more and more time at his studio in Holland Road. He worked hard and on 28th April, 1905 held an exhibition of 'Sketches of British Sport' at the Galleries of the Directors of Messrs. Graves & Co., at 6 Pall Mall, which was quite successful. One day he suggested to Ethel that as he was now earning between £400 and £500 a year, which he considered an adequate amount on which to support a wife, they should be married and set up in lodgings on their own. Ethel, feeling that since both her sisters were living at home at the time, her family could do without her, agreed, and on the 20th October, 1905, they were married at the Kensington Registry Office, Lionel being twenty-six, and Ethel twenty-four. Ethel recalled afterwards that when the Registrar asked for her father's name and address, she exclaimed in alarm, "You are not going to write and tell him are you?"

Much amused, he replied, "Thank goodness, my dear young lady, that is not part of my duties."

They went for a short honeymoon to Exmoor, with which Ethel fell in love as much as Lionel had done. In the meantime the ménage at Warwick Studios had come to an end. Fitz and Clare found somewhere else to live for the remainder of his leave, and Lily, refusing to divorce him, went to Italy, where she became a Roman Catholic and entered a nunnery. She corresponded regularly with Harriet during the latter's life-time, and afterwards intermittently with Lionel, who gave her news of Fitz, and in her old age, when the nunnery had become poverty-stricken, sent money. She died sometime during the Second World War.

When Lionel and Ethel returned from their honeymoon, they had

perforce to live with Harriet, since the latter could not afford to live on her own. The anger of the respective parents having now somewhat abated, Lady Maine insisted that the couple should have a church marriage as well, and be given a small reception which she held for them at Cornwall Gardens. She would allow no recriminations, which, she said, were of no use and made everyone unhappy.

Lionel settled down again, and on the 18th January, 1906 held a small exhibition at Warwick Studios. Very strangely, on the back of the invitation card, which we still possess, is a sketch of Ethel surrounded by rabbits!

There is an early picture of Ethel, a water colour, dated 1902, which was very kindly given to us by the Hon. Aylmer Tryon. Entitled 'Sugar', it shows Ethel in evening dress, in a stable, feeding a dark brown horse with sugar. The figure, though unmistakably Ethel, is very stiff, but the horse, the stable and the straw are painted with great attention to detail. The style, however, is totally different from that of Lionel's later years.

The few photographs of the young couple which still exist are posed and stiff, but they look very much as I remember them when I was a small child. Ethel was short with a neat figure and small hands and feet. She had masses of long dark hair which she had always great difficulty in controlling to keep it in the 'bun' which was then the fashion. She also had a beautiful complexion which, untouched by any cosmetic, remained with her all her life. Her greatest attraction was her eyes, long-lashed and greenish hazel which altered in expression with every change of mood. One moment they could be gentle and sympathetic, the next sparkle with fun, gleam with a sudden amusement or flash with anger at some story of cruelty or injustice. Her voice, which she never raised, was low and pleasant, even when she described with gusto the awful punishments she would like to inflict on anyone cruel to children or animals. She was very shy, due, she always said to the fact that she so often felt herself badly-dressed and uneducated among people who were neither and could not therefore be expected to understand what it felt like. According to Lionel, the initial shyness soon disappeared and she then greatly enjoyed any party or entertainment to which she had been invited.

Lionel was one of those who are much better-looking in middle and old age than in youth. When young he was certainly the plainest of the five brothers, but no one could have called him ugly. He was only just

six feet, but being always slim, looked taller. He had an exceptionally small head, so that hats always had to be made for him. His features were indeterminate, the mouth being covered at this time by a heavy moustache. He had dark hair and grey eyes which in all the photographs look straight at one, with a serious and thoughtful expression and appear to be as observant as they undoubtedly were. His long arms—the sleeves of his coats were always too short—ended in bony wrists and large hands with long slender fingers. Throughout his life people found him attractive because he was so alive, his whole face beaming with enthusiasm as he talked of his many interests, or alight with mischief as he described some amusing incident or told some story. When he was excited, which was often, his voice would rise and become louder and louder, until at last Ethel would say, "Don't *shout* so, darling," which would quieten him for a few moments, until he forgot and got into his stride again.

A year or two after their marriage, Lionel and Ethel, together with
Harriet, took a house near Oxford at the instigation of Sir Frederick
Preston, whose wife was a relation by marriage of Lionel's half-sister,
'Tottie' Peters.

The Prestons lived at Milton Hill and were extremely kind to the
young couple, lending them horses before they could afford their own
with which to hunt with the South Oxfordshire, the Old Berks and Sir
Frederick's own pack of harriers. At some time during this period
Lionel painted his first large equestrian portrait, that of Lady Preston,
and also some old-time hunting scenes on six wooden panels, placed
round the top of the walls in the hall at Milton Hill. When many years
later the house was bought by a petrol company the panels were
dismantled and sold.

Ethel now had her first taste of real hunting and enjoyed every
minute of it. She had beautiful 'hands' and all horses went well for her.
They also went well for Lionel, in that they had to jump anything and
everything that was set before them, but all his life his excitability and
nervous temperament found both himself and his mount far more
exhausted than they need have been by the end of the day.

In due course Lionel was earning enough to buy inexpensive hunters
for both himself and Ethel. One, a good-looking grey, named Gay Lad,
remained with them until, in old age, he had to be put down at the
beginning of the 1914 war. He was always remembered with great
affection and appears in many of Lionel's pictures of this period.
Ethel's mount, on the other hand, was a bay polo pony called Jester,
bought from a dealer for less than the latter had given for it because, as
he said, "Polo grounds were not made large enough for it." Ethel who,
of course, rode side-saddle, became accustomed to being run away with
from the start to the finish of every hunt. The pony had a mouth like

iron, and people would shout to each other when coming to a jump, "Look out! Clear the way. Here comes Mrs. Edwards. Let her go first!" The pony was as clever as a cat, and would take on anything except water. Soon after Jester had been bought, Gilbert Holiday came to stay and was offered Jester for a day with the Old Berks. They charged the Rosey Brook, and according to Lionel, Gilbert Holiday determined to go on, and the pony deciding to stop, both went in the middle.

'G.H.', as he frequently signed himself, was at this time making a name for himself as an artist with his drawings for *The Graphic*. Lionel admired his work, and said of him, "To my mind Holiday was almost the first artist to master the photographic action which we have become so accustomed to see in the daily and weekly press. By this I mean animals in motion as seen by the camera and not the artist's entirely conventional rendering with which our forefathers were perfectly satisfied. Now, so accustomed have we become to the strange actions seen by the camera, but not by us (as its lens is so much faster than our eyes) that it is the old positions which seem absurd. Holiday, by clever manipulation of dust or mud and the consequent blurring of outlines, was able to give a tremendous sense of speed. When dealing with a mass of horsemen he was even better and he would use the most grotesque positions with success."

In 1907, when Ethel became pregnant, she was ill and remained so during most of her pregnancy. She starved herself, so that not surprisingly, I was born a very delicate baby, having, for some reason, to be brought up on goat's milk. The strongest impression I appear to have made on my parents was that I cried incessantly, loud and long, both day and night. When the monthly nurse became too exhausted to cope any longer, I was taken into my parents' room at night and in turn they walked up and down with me, trying to get me to sleep. Ethel always remembered how Lionel, a large and bony hand grasping me tightly by my nightgown, in the middle of my back, and holding me almost upright, would march up and down the room muttering, "Go to *sleep*, you little devil," but, apparently, I never did. When, fifteen months later, while still living near Oxford, my brother Derrick was born, Ethel was desperately ill. She had scarlet fever at the time, but owing to a chill, there was no rash and no one realised she had it. When very near to death, she heard the doctor say to the nurse, "She's gone," but though too weak to open her eyes, she was in fact (so she said afterwards) listening to the most beautiful music, and was very reluctant

indeed to return to the effort of living. The consequence of this experience was that never afterwards, throughout her life had she any fear of dying.

In the spring of 1910 Lionel and his family moved from Oxfordshire into the Croome country. They rented Norton Vicarage, which can seldom have had such unconventional occupants. The church was close by and a not very long orchard separated the Vicarage garden from the churchyard. Into this orchard went all the members of Ethel's menagerie. There were five goats and a billy aptly named Beelzebub, cocks, hens, ducks, geese and very often the two horses. As Jester never stayed anywhere if he could possibly jump out, and Beelzebub several times stalked up the aisle during matins (introduced, it was suspected, by the drummer boys who came on Church Parade from Norton Barracks) Sunday was a constant anxiety. Occasionally also, Nogi and Togo, the two fox terriers, who were brothers but hated each other, would guess where their master and mistress might be and, having found them, would fight furiously in and out of the pews.

These incidents, however, were insignificant when compared with an event which occurred shortly after the arrival of the Edwards family at Norton. Lionel had bought from a cousin an excellent trap—a large governess cart made of boxwood, beautifully upholstered, with lancewood shafts, and so light and well-balanced it could be moved by one finger placed under a shaft. It also had brass fittings and rubber tyres. One day Harriet announced that she would like to go for a drive that afternoon, and being quite fearless where horses were concerned, was not at all disturbed when Lionel said that as Gay Lad was lame, Jester, who had never been in harness before, should take his place. Under the circumstances, Lionel would accompany Harriet, and he or Ethel would drive. All went well until, in a quiet country lane, Jester suddenly shied violently. The trap hit a telegraph pole, the near-side wheel came off, and they were all thrown out. Lionel picked himself up and raced after the pony, which had bolted, while Ethel, also unhurt, went over to Harriet who had been thrown into the ditch and on to a bed of nettles. She was very shocked and upset, but managed to walk with Ethel to a nearby farmhouse, where the farmer, very sympathetic, plied her with whisky. After a time, he kindly offered to drive them home in his pig-cart, the only conveyance he possessed. So, on clean straw, Harriet lay in the back of the cart while Ethel sat with the farmer in front. To any enquirers they met on the way, the farmer replied,

"'Tis the poor lady from the Vicarage, not really hurt, just the whisky, you know." This opinion was confirmed by the doctor who Ethel called in directly they reached home. Jester returned unhurt and the trap was repaired and served the family for many years. Lionel would never part with it even when it had to be superseded by a car.

Ethel and Lionel now hunted regularly with the Croome, the Master at this time being Lord Charles Bentinck, considered by many to be the best amateur huntsman of the day. The young couple made many friends, and it was with regret that in 1912, Benarth being no longer let, it was felt that the family should return to Wales to live in the old house themselves.

CHAPTER ELEVEN

Lionel said of himself of this period, "As I acquired first-hand knowledge of the chase, I found a better market for my pictures," but what this market was is now difficult to trace. There were commissions as well as work for the Press, and these occasionally come to light, as do water-colours of military subjects. These are usually of cavalry, either Indian, or of French or Russian soldiers of the Napoleonic Wars. In all, the uniforms and accoutrements of the period are absolutely correct.

When Lionel was asked to illustrate a book called *The Guadalquiver* by Paul Gwynne, published by Constable in 1912, he and Ethel were lucky enough to be invited to join the Prestons on their yacht. They were going to Spain, ostensibly on a pleasure trip, but in fact, I believe, on a diplomatic mission. This entailed their remaining in the country for some time, which enabled Lionel to sketch and paint a diversity of subjects and places. There are no less than forty-four illustrations in the book. Some of these are done in a flat wash outlined with a black line, a method Cecil Aldin also used at this period. Most, however, show a developing style in which Lionel used a great amount of white together with water-colour, the result of which is quite astonishing in its strength and brilliancy. Some of the pictures were on white paper, some on coloured, and some of the originals are on wood.

Both Lionel and Ethel loved Spain, its sun and colour and the unspoiled countryside and people; but they also saw some of its less pleasant aspects. Struck by the number of small crosses by the wayside and outside the inns, they were told these were 'accidents', but Paul Gwynne mentions in his book the frequent stabbings and knife throwings which took place at this time. It was a state of affairs which was finally ended by the rather brutal efficiency of the Guardia Civile. One day Lionel met two of the latter on a country lane escorting a prisoner. Their horses were trotting fast, the prisoner running between

them, his hands tied behind his back, one end of the rope being held by each of his captors. The sun was hot and the man stumbling with exhaustion, but there was no slackening of the pace.

Ethel always remembered how a corpse lay for four or five days on the quay at Seville, near where the yacht was moored. A stolid guard sat beside it, smoking, waiting till the powers that be should authorise its removal.

Since the Prestons were important visitors they felt it necessary to attend a bull-fight when invited to do so, but it was with great difficulty that the ladies were persuaded not to leave before the end. Lionel was excited by the colour and pageantry of the spectacle in the brilliant sunshine, and admired the skill and bravery of the performers, but he too felt that nothing could excuse the slaughter of the horses. If it was a strong bull there would some times be six or eight lying dead or dying in the ring at the same time. As for Ethel, she was so filled with fury and disgust that she wished aloud for the death of each matador as he entered the ring. The fate of the bulls was a different matter. Bred to fight, most died fighting valiantly, a better death, perhaps, than that of the slaughter-house.

A sight which Lionel was always glad to have witnessed was the bringing in of the bulls to the bull-ring before a big fight. This took place on a moonlight night, watched from a safe distance by spectators. The bulls galloped by in a cloud of dust, led by a picador, who kept glancing behind at the leading bulls to measure his distance. Had his horse stumbled and fallen neither of them would have risen again alive. Behind the bulls came more horsemen with lances, and men on foot shouting in wild excitement. Lionel's illustration of this event is one of the best in the book.

By the end of their visit all on the yacht had grown used to the multifarious debris which constantly floated by. This consisted not only of every kind of refuse, but also of dead animals, chiefly donkeys, horses, dogs and cats. The Prestons had with them their two sons, Brier aged thirteen and Jocelyn, who was ten. One morning Brier saw a drowning kitten close to the yacht, and jumped into the water to rescue it. This was believed to be the cause of the tragedy which followed. Some days later, on the voyage home, Brier went down with typhoid fever, and at the same time the yacht was becalmed. The latter had no engine, and they were too far from the sea-lanes for ships to see their signals. When it became obvious that Brier was desperately ill, his

father asked for volunteers to row as far as the sea-lanes where they might hope to intercept a ship. They were able to stop a Portuguese ship with a doctor on board, which altered course and went to the yacht, but it was too late, and Brier died. Since various formalities had to be attended to, the yacht returned to Seville as soon as possible, and here Lionel and Ethel and Jocelyn, who they had been asked to take with them, joined a German ship and came home.

Sometime during the autumn of 1912 Lionel went to Germany to illustrate another book, *The Moselle*, by Charles Tower, published by Constable in 1913. The many illustrations are good examples of his earlier work, some pure water-colour, others using white paint and water-colours on dark paper.

Lionel was accompanied by Ethel and her eldest sister, Cissie, whose ability to speak French and German made the journey much more interesting. Germany was at this time a very male-dominated society and Prussian officers a very privileged class. When a woman met a group of the latter she was expected to step off the pavement into the street to let them pass. Ethel and Cissie refused to do this. They merely linked arms, stood still and waited. The result was sometimes very funny, but in the end the officers would give way, with furious glances at the obvious amusement of Lionel and other onlookers. Lionel, as usual, spent his time making sketches of whatever interested him, but those of the German officers usually had to be made on shirt cuffs or menu cards under the shelter of a restaurant table.

When Lionel and Ethel returned to Benarth life went on much as before except that there was an ever-increasing shortage of money. In spite of Lionel's hard work and his brother Arthur's strenuous efforts to improve their mother's finances, it became more and more difficult to keep the estate.

About this time a young Canadian cousin, Stanton Bruce (afterwards General Bruce, one of the founders of the Malay Regiment), was up at Cambridge and frequently spent his holidays at Benarth, usually accompanied by a friend. On the last vacation, before returning to Canada, Stanton brought with him a young German, Herbert Poelhau, who returned to Benarth for every vacation until the outbreak of war, when he was suddenly recalled by telegram while with us, and never

came back. Ethel had become as fond of him as of a young brother. He was tall and very fair, with blue eyes and charming manners, as I remember him when he used to play with us. His father was a great friend of the Kaiser, to whom he would lend his yacht if it was thought that it would win against the Emperor's own. Ethel thought this a strange idea, but Herbert found it perfectly natural.

All through the war Ethel kept Herbert's belongings, and was very glad when in 1920 his mother was able to get in touch with her through Herbert's former tutor at Christ's College. From the black-edged envelope Ethel sadly guessed the letter's contents. It is written in excellent English, a very long letter, from which I quote. She asks for news of us all "as your husband had still the age for military service and the Influenza had been raging in England, as here." After saying how glad she is that Christians understand each other, in spite of "these poisoned instruments" the newspapers, she continues: "Do not be astonished at my asking so much, but everything connected with you and Benarth Hall is dear to me. It was my boy's paradise, his last golden days. He fell in March 1916 by a big shell, so did not suffer at all, and never had to fight against English troops; that gave him great satisfaction. But I *never* saw him again although I had every second day a letter since he left us in September, 1914. In March 1917 his two elder brothers fell. One was buried by the Russians, and in summer 1918, our darling, their young sister died, as sister of the Red Cross, from typhoid fever. God has made our house very empty, but all my children believed fervently in God."

Ethel kept this letter and she and Frau Poelhau corresponded regularly for the next two or three years, then letters from the latter ceased and it was presumed she had died.

The 'last golden days' of 1914 were not only only those of Herbert Poelhau but also of the Benarth he knew. During the first months of the year nothing untoward happened. There are snapshots of Herbert, of Lionel's new horse, Susan, of Ethel with various members of her animal family, of Harriet giving sugar to the horses, and of Derrick and myself in sailor suits in our donkey cart. There are also snapshots of Lionel and Holloway, the groom, breaking in the small Welsh pony which had been bought for me at Llanbedr Fair the previous year. She had been led through the house from the back door to the dining-room as a birthday surprise, showing then the gentleness and equanimity which never left her throughout her long and useful life. She was also broken

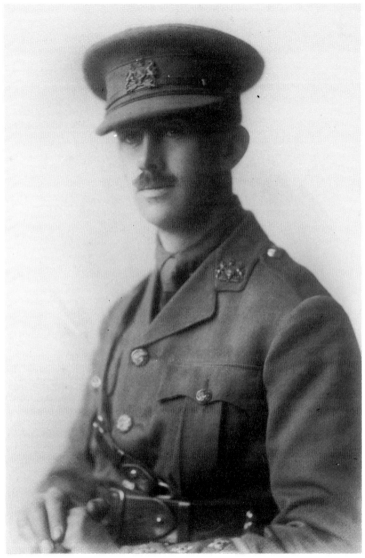

Lionel Edwards as a soldier, World War I.

to harness, a small trap was bought for her, and during the war she was Ethel's chief means of transport.

Although, no doubt, Lionel worked as hard as ever, there are very few examples of his work dated 1914. He was away a great deal, happily leaving, as always, all the financial worries connected with Benarth to be dealt with by his brother Arthur, who came over more and more frequently from his home at Portmadoc. In Lionel's eyes, whatever Arthur said or did must be right, and his decisions were never questioned.

When it became inevitable that Benarth would have to be sold, Arthur wrote to Fitz, who was abroad with his regiment. Fitz replied that, as he had no heir, would not be leaving the Army for some years, and would not wish to live in Wales anyway, he would raise no objection to the sale. Lionel and his mother accepted the decision calmly, even with a certain degree of pleasure, since Lionel hoped to be able to live in a better hunting country, and Harriet to live in London. Only Ethel grieved bitterly, and throughout her life maintained that the sale had been unnecessary. She thought that if she had been allowed to take paying guests, it might have been possible to keep, if not the land, the old house.

When war was declared on 4th August, not many people realised that, as Earl Grey said, the lights were going out all over Europe. Even after the various rumours of Russians with snow on their boots and rebellions in Ireland had been discounted, it was not recognised that England was engaged in a full scale war. Most thought that it would be over by Christmas, after which normal life could be resumed. Arthur insisted that preparations for leaving Benarth should continue so that the sale could take place, as arranged, in the spring. Ethel was pregnant, and it was decided that no changes should take place until after the arrival of the baby. Philip Gamul was born on 3rd January, 1915, after which events seem to have taken place with incredible speed and finality. Holloway was called up, and the horses had to go. Susan, Lionel's new hunter, was taken by the Remount Service, Jester and Jorrocks the carthorse were sent to Jim Francis's stables at Colwyn Bay to be put to any use which might save them. I remember as a seven year old going into the morning room and finding my mother and grandmother in tears and Lionel near to joining them. Gay Lad was to be put down, as were Nogy and Togo the terriers, and Harriet's collie. All were old, and there was nowhere for them to go. Harriet was to stay,

for the present, with Mary Peters, Lionel's half-sister, in a small house
at Richmond, while Nannie and we three children were despatched to
stay with an elderly cousin at Eastbourne until a new home be found.
The difficulties and sadness of this time fell hardest upon Ethel. She
loved Benarth, and minded leaving more than either Harriet or Lionel,
but she it was who finally had to say goodbye to the tenants, who had
come in a body to offer to raise their rents, if this would save the estate.
She also had to part with the servants, some of whom were real friends,
particularly old Margaret, who had worked at Benarth since she was a
girl, Hicks, the parlourmaid, and dear Fred, still the under-gardener.

The bloodhounds had been sent away, and I believe most of them
were killed later because of food shortages. The stables were empty, the
gardens neglected, and most of the beautiful old furniture in the house
was to be sold. Nevertheless, Ethel wished to attend the sale, which
took place on 2nd and 3rd March, 1915. She stayed with the Woods at
Bodlondeb and went each day, watching as (according to the catalogue)
"the contents, including the collection of valuable antiques, embracing
some rare examples of the XVIth, XVIIth, and XVIIIth centuries"
were sold, fetching almost nothing in those uncertain times.

Lionel, meanwhile, spent most of his time in London, obsessed with
anxiety lest he should be unable to join up. For some reason he never
tried to become a war artist, but he must have done some work, for, in a
letter to Ethel from Frau Poelhau after the war, she says that when
Herbert went into Belgium with his regiment in the autumn of 1914,
"he found in Belgium an English paper with an illustration of war
action by your husband and wrote 'I knew it before I saw who signed.'"

Lionel besieged the War Office, and wrote desperate letters to anyone
whose inluence he felt might help him. It would seem that it was a letter
from Lord Charles Bentinck which finally did so. The latter must have
sent the reply, from a gentleman at the War Office (whose signature I
cannot read) direct to Lionel. It begins:

> "My dear Bentinck,
> Many thanks for sending me Lionel Edwards's name,
> which I have noted. Would you mind sending me a
> postcard saying how old he is? We have so many old
> gentlemen of 45 to 60, but find people of subaltern
> standing, to knock about our depot and train horses at night
> and so forth, difficult to come by."

Lord Charles must have satisfied the writer as to Lionel's age (he was now 36) and capabilities, for the next letter he received from the War Office, dated 25th March, 1915, was as follows:

"Sir,
I am directed to inform you that you have been appointed a Second Assistant Superintendent, with the Temporary rank of Captain, from 31st March, 1915, to the Remount Depot at Romsey.

You are requested to report yourself on the 31st March to the Commandant, Lt. Col. H. M. Jessel from whom you will receive further instructions."

So Lionel became a soldier.

CHAPTER THIRTEEN

Lionel having been instructed to report to the Romsey Remount Depot, found when he arrived only a tin hut, containing★ "an extremely grumpy adjutant, a staff sergeant and a couple of clerks", and was instructed to "clear out and wait until I was sent for". He and Ethel then spent six weeks at the "White Horse" in Romsey and went house hunting in the neighbourhood. They found Rose Cottage in the village of West Wellow, and this was our home for the next two years. The family, which moved in immediately, now consisted of Derrick, Philip and myself. Nanny having had to leave us, Ethel only had to help her Grace, our Welsh cook, the same Grace who Lionel had tied to the railings as a little girl when he was about five years old. She had a deep voice with a very Welsh accent, was as strong as a horse, and could and did turn her hand to anything indoors or out. She had a great affection for "Master Nello", as she called my father, and was also Ethel's firm friend and ally.

Very soon after we arrived at Rose Cottage Derrick and I went down with scarlet fever. Grace took Philip to stay at a nearby cottage and Ethel nursed us. We had it very slightly, but when Ethel caught it she was very ill indeed, so that when a hospital nurse was finally obtained, she could pay very little attention to Derrick and me.

One morning we were sitting on the window sill in our nighties, with our feet out of the open window, when a Major Jepson Turner brought his men on exercise along the road in front of the cottage. We knew him well, and seeing us he ordered us to get back into bed. The horses' bits jingled and glittered in the sunlight, the men laughed and waved, we waved back and took no notice of the order.

"I shall tell your father and then he will spank you," said Major Turner.

★*Scarlet and Corduroy.*

"He isn't allowed in the house," we replied gleefully. "He has to talk to us through the window from the top of a ladder."

Major Turner then promised to put a box of chocolates on the gate post the next day if we would go back to bed at once. This we did, and he was as good as his word. A veteran of the Boer War, unmarried at the time but very fond of children, he often came to Rose Cottage, and also several times took horses overseas in Lionel's place, saying that the risks involved should not be incurred by the father of a young family.

Lionel made many friends at the Romsey Depot, not only among the officers, most of whom were elderly cavalry officers, Masters of Hounds, racehorse trainers and the like, but also among those of 'other ranks' huntsmen, grooms, jockeys and one or two of the Canadian cowboys, of whose skill with the lariat and in riding in their own Western style saddles he made many sketches. Lionel said in *Scarlet and Corduroy*, "Life in a Remount Depot was extremely dull, I imagine, to most men, but not to me—to whom the horses were a ceaseless interest." That this interest extended to every aspect of equine life is shown by the sketches which survive, and by a letter from Major-General F. Smith, D.D.D.V.S. Southern Command, to Major Baldrey, A.D.V.S. Romsey, dated 11th March, 1916, which says: "With reference to your memorandum of the 19th instant, together with water-colour drawings of the eruption,* from the brush of Captain Edwards, will you please convey to this officer my personal thanks for the great trouble he has taken in furnishing us with a permanent record of this very interesting affection, which I have had much pleasure in transmitting this day to the War Office and subsequently to Sir John McFadyean for his information. I hope Captain Edwards will allow me to retain this beautiful work."

Now and again Lionel managed to get some hunting, either with the Hursley, the New Forest Buckhounds, or with the New Forest Foxhounds, then hunted by Major Tommy Timpson, a brother officer and a great character. Occasionally Lionel was lucky enough to have a day with the Duke's, then being hunted by another brother officer and great friend, Captain Herbert Nell.

Lionel found that through riding many different types of horses, some half-broken, some vicious and many coarse-bred, his nerve

*Presumably some equine disease.

became less good, and did not recover until he had had several seasons hunting after the War.

Towards the end of 1915 Harriet died of cancer, after a long illness which she bore with great courage. She had had to remain at Richmond, and though Lionel went up to see her as often as he could, she saw little of him, and separated from her grandchildren, whom she greatly missed, the last few months of her life were, sadly not happy ones. Fitz came home on compassionate leave, but he and his mother had never understood each other. Arthur, who had done more for her than anyone else, she had never really cared for.

While in England Fitz stayed much of his time with us at Rose Cottage. I can see him now, for some reason in his socks, making cavalry charges up and down the road in front of the cottage with Derrick piggy-back. When his uncle's leave was ended Derrick tried to postpone his departure by throwing his hat into a tree, which made the General (as he had now become) lose his train.

During the War Fitz commanded a cavalry brigade in France under Sir John French and Sir Douglas Haig, and an infantry brigade in 1917 under General Allenby in Palestine. Mentioned in despatches four times, he was awarded the Order of the Nile, 3rd Class, a C.B. and C.M.G., and in 1917 became A.D.C. to the King. He retired from the Army in 1919 and bought a farm in Devon, then moved to Sussex, where he lived with Clare and her two girls until his death in 1929.

In 1916 I had rheumatic fever, a result, I believe, of having scarlet fever, and was in bed for several months. Ethel, finding it difficult to manage us all, sent Derrick to a preparatory school in Scotland, the headmaster of which was a great friend of Arthur's. It seems an extraordinary thing to have done. Derrick was only seven and the journey involved crossing London at a time when Zeppelin raids were frequent, and travelling extremely difficult. Once Ethel thought the Scottish train in which Derrick was returning for the holidays must have been bombed, for it was during a raid, and hours late. In fact, because of the raid, the train had been halted outside London.

Embley Park, near Romsey, formerly the home of Florence Nightingale, was, together with the estate belonging to it, owned at this time by a Major and Mrs. Chichester. The latter was a great friend of Ethel's, and thinking that my rheumatic fever was caused by living in a damp cottage, persuaded Lionel to rent from them Manor Farm, at East Wellow. The old house, built on the site of a much earlier building and

close to the Norman Church, had an interesting history and was supposed to be haunted by a headless Cavalier. He was to be expected at midnight on Christmas Eve, but though Lionel and Ethel waited up for him, he did not appear on that, or any other occasion.

In 1917 my brother Lindsay was born. It was also the year of the great influenza epidemic, and it seemed as if the bells of the nearby church never ceased tolling.

In 1918 a tragedy occurred from which Ethel never quite recovered. Derrick and Philip and I had our tonsils out and shortly afterwards Philip became ill. The old doctor did not realise how serious it was, and when, after days with a very high temperature, Philip had an operation, it was too late. He died of blood-poisoning due to a swab having been left in his throat. Lionel and Ethel were overwhelmed with grief, but, strangely, with Ethel, it took the form of rejecting Derrick and myself. Nothing we could do was right, and we were forever being scolded for something. We were becoming sullen and disobedient when Lionel evidently decided something must be done. To our surprise, for it was unlike him, he asked us to go for walks with him, played Indians with us with the pony, Mollie, and, scratched and torn, forced his way into our 'house'—a very large hole in a very thick hedge, where we all ate biscuits in great discomfort. One day he took us potato-digging in a small field nearby. Derrick and I made a bonfire in which to roast our potatoes, and after a short while Lionel joined us. Sitting down beside us, he asked if he could roast his potato also, and then said, "You mustn't take any notice when Mummy is cross. She just hasn't been well since little Phil died." Too surprised to say anything, we sat stolid and silent until Derrick suddenly remarked that his potato had got lost in the ashes, after which we all relaxed.

In December, 1918, the sale of horses from the Remount Depot began, and Lionel took them to sales all over England, especially to Birmingham, Bicester, Leamington and Oxford. He kept the lists of horses to be sold. They were sold in lots, with comments beside each number, and it is a sad reflection on the men looking after them towards the end of the War that in almost every case the remark was "Timid", "Nervous", or "Very nervous about the head". It was not entirely the men's fault, for, as Lionel said afterwards, "The continual medical boards, whose job it was to find replacements for the fighting units, eventually left us with a very mixed bag, most of whom had never seen a horse before."

Lionel himself bought four horses. One, "Boxer", was apparently mad, for he would suddenly, for no reason, go berserk while being ridden. He had to be destroyed. "Springheel", a lovely hack, was bought for Ethel, and Lionel also bought "Tommy", the fastest horse in harness we have ever owned, and "Ginger", an American horse, very ugly, but a marvellous hunter. Lionel painted a portrait of him for Ethel, entitled "'Andsome is as 'andsome does". His only peculiarity was that he occasionally jumped a shadow on the road, thinking, apparently, that it was a snake.

When Lionel was demobilised in January 1920 he wondered how he would manage to support his family without even a Captain's pay to augment the not very large income he obtained as an artist. He now had four small children, my youngest brother, Kenneth, having been born the previous September. Shortly after his birth we had to leave Manor Farm at East Wellow when the Embley Park Estate was sold after the death of Major Chichester. We moved to Mainstone House on the Broadlands Estate, the house being at the foot of Pauncefoot Hill and just outside Romsey. Since neither Ethel nor Lionel wished to live so near a town, they went house-hunting again. They hoped to find some cottage in a near-by village. Ethel was greatly dismayed, therefore, when Lionel returned one day from hunting with the Hursley and told her that he had found a house on the Downs beyond Broughton, that it was to let, and that he was determined to have it. He admitted that it was rather large, but it had a lovely view which was much more important. Fortunately, when Ethel saw it, she also liked it, and it remained their home, very cold and inconvenient, but much loved, for the rest of their lives. Buckholt had originally been a farmhouse which had been burnt down at some period, so that only the old kitchen and stone-flagged passages of the back premises remained. When rebuilt it was enlarged and later let as a private house by the Norman Court Estate, which kept the farm in hand. Early Victorian in style, the house had a slate roof and was of red brick, but the front had been faced with a very ugly yellow brick, over which Ethel longed to grow creepers but was not allowed to while we were tenants. The square solid porch had a flat roof, on to which we children would climb from an upstairs window, when playing hide-and-seek, letting ourselves down on to the sill of the window below. The flagstone which formed the floor of the porch must have been very old, for it was so worn and dented in the centre

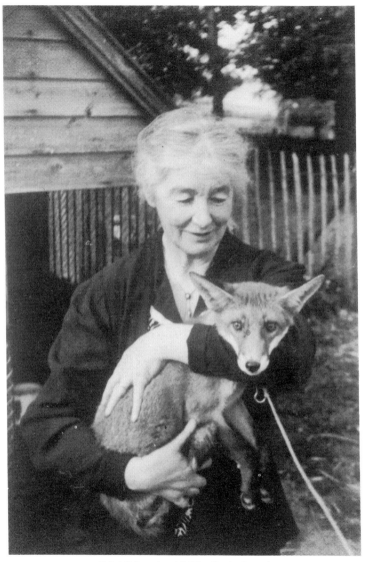

Ethel Edwards with Charlie the fox cub.

by many feet that snow or rain would be driven, not only under the heavy outer door, but under the inner door also, right into the hall. The rooms all had rather lovely sash windows, but these too were old and on windy nights they clattered and crashed so that my youngest brother, lying in bed, would imagine they were ship's guns and he was taking part in some great battle with Nelson or Collingwood. The cellar Ethel turned into a dairy and I remember listening to the hum and turning of the churn as we sat in the schoolroom above. Since there was no heating of any kind other than coal or log fires, the house was both cold and damp in winter, but it was sunny and spacious, and had a happy home-like atmosphere.

One of the attractions of Buckholt from Lionel's point of view was an extremely ugly extension at the back, on the north side. Built of corrugated iron and wood, it had been used by the previous tenants as a billiard room, and became Lionel's studio. He put a skylight in the roof which nothing could stop leaking in really wet weather, so that he had to pick his way to his easel amongst various utensils put to catch the drips. This worried him not at all, nor did the draughts from the six large but ill-fitting windows, nor the smoke from the tortoise stove, which engulfed the room when the wind was in a certain direction. In the latter case he merely opened all the windows, so that he might as well have been painting out of doors.

The studio was treated with scant ceremony by the rest of the family. Occasionally bicycles or perambulators were left there, or sick animals or birds, such as ducklings brought in from a thunderstorm, or a pet which it amused Lionel to have with him while painting. Sometimes he would fetch my rabbit, of which he was as fond as I was, from his hutch. Rab, fourteen years old when he died, had been acquired when I had rheumatic fever, and at Lionel's instigation, would be brought to my bedroom to amuse me by his antics while I lay in bed. At Buckholt he would play happily in the studio until the dinner bell rang, then, hardly waiting for the door to be opened, would rush down the stone passage through the hall and into the dining room at the other end of the house, where he would sit up and beg, waiting for the bread which he knew would be forthcoming when Lionel arrived.

At the beginning of the Second World War Ethel's fox cub, Charlie, was one day left in the studio, by mistake, at lunch time. On returning afterwards Lionel found the room knee deep in paper. Charlie had spent the time jumping up at and ripping down the Home Guard maps

which Lionel had carefully pinned all round the walls the day before. Presumably the cub had enjoyed the sound of tearing paper.

The old stables and outbuildings were often painted by Lionel and appear in many of his pictures and illustrations, especially those in *Stable and Kennel*. The very good stables went with the house, as did the outbuildings. The kitchen garden is surrounded by a cob wall, but the rest is open to every wind that blows, and from it one can look across to the Isle of Wight, thirty miles away.

When we arrived in August 1921 it was in the middle of a drought. The only water available came from a very deep well between the stables and the house. When we became ill Lionel had the water analysed and it was found to be undrinkable. Water was brought to us daily in a water cart.

Lionel always said that had he taken a house in the Shires, as he would have liked to have done, he would have hunted every day, never finding time to do any work. Having however settled on a shooting estate he found it extremely difficult to accommodate himself to its ways. As a naturalist he deplored the habit of old-fashioned keepers of killing any bird or animal which remotely resembled a predator, and this meant also, of course, that every keeper was a potential vulpicide.

Buckholt being in the middle of his best partridge shoot, Mr. Washington Singer, who owned Norman Court Estate, would only let it on a six month's tenancy. This caused Ethel a great deal of worry, and she continued house-hunting in a desultory manner for many years. She was convinced, not without reason, that Lionel would one day say or do something that would make Mr. Singer wish to be rid of his temperamental and sometimes unruly tenant. In fact, however, Mr. Singer proved to be a most kind and tolerant landlord. Not only did he allow us to ride anywhere on the estate, but also we children, with Nanny or governess, would go for long walks taking three Welsh collies and a goat with us, which, without let or hindrance, roamed far and wide at all seasons of the year.

When Mr. Singer died and Grant Singer inherited the estate, he too was a most kind and considerate landlord, and we felt it as great a tragedy as did all who knew him when he was killed during the Second World War. The estate then had to be sold, and Lionel bought Buckholt, together with the surrounding fields and a small farm adjoining it for my younger brother.

CHAPTER FIFTEEN

Lionel first began to keep a diary the day he was demobilised on Tuesday, 11th February, 1919. All the previous pages for this year are carefully crossed out with thick pencil lines. Thereafter he kept one regularly for the rest of his life, but it cannot be said that they make interesting reading in themselves, for they were kept purely as memoranda of the work he had been doing, with only occasional references to other matters. These usually concerned his day's hunting, the following entries from his 1919 diary being typical:

"25th October. Saturday.

Hunted with Quorn (Castle Donnington). Gay horse—good looking but unsound. Moderate sort of hunt—market gardens and water meadows.

28th October. Tuesday.

Hunted with S. Notts. Ran over nice country. Killed at Giddington (got mask).

30th October. Thursday.

S. Notts. at Cotgrave—rotten day—no foxes—big woods.

1st November. Saturday.

Earl of Harrington's—fairly good hunt—nice country—no wire."

There are, too, brief notes of shooting parties. These he liked more because he enjoyed meeting people than for the sport itself, although he was quite a good shot.

The main interest of the diaries is the record they provide of the astonishing amount of work Lionel produced, much of it being sent, almost daily, to A. E. Johnson, who became Lionel's artist's agent in 1906. Together with E. W. Boot, Johnson ("A.E.", as we always called him) remained his agent until his death. They also became firm friends, and often stayed with us. "A.E." was in every way a big man, tall and broad with a large head. He had a nice sense of humour and a great love

of literature from which I profited, as he often brought me books. E. W. Boot, on the other hand, (I never discovered his Christian name), was short, slim, quiet and gentle, except on the subject of the Germans, for whom he had an undying hatred. He had been in Germany in 1914 at the outbreak of war and was interned for the duration.

"A.E." 's business premises were at first at 10 Lancaster Gate, in the Strand, than at 3 Portsmouth Street, Kingsway, then 3 Henrietta Street, Covent Garden and finally and until his death, the Sporting Gallery, 32 King Street, Covent Garden.

Lionel being completely uninterested in money, except as a necessity, and having very little business ability, relied on "A.E." to make arrangements, deal with difficult customers and unravel as best he might the intricacies of the laws of copyright. Lionel also, of course, frequently accepted private commissions. Everything was grist that came to his mill, and was executed with great promptitude, as can be seen from the following entries in his 1919 diary for three consecutive days:

"Monday, 24th February.
Sent Ivor Anthony sketch of J. Anthony on Ibstone.
Tuesday, 25th February.
Sent Johnson 2 (colour) Remount sketches.
 "The Docks".
 "Evening Stables".
 2 (colour) hunting sketches.
 The Ledbury and
 Flint and Denbigh.
Wednesday, 26th February.
Sent Johnson 4 pencil sketches of the Hursley.
 4 originals "The Seasons".
 (for Buick cars)
 1 poster Aintree biscuits.
 and 4 pen sketches for motor books.
Sent rough sketches for *Romance of the Road.* to McKay at Lyndhurst. Lt. Todd called. Wants sketch for Queen's Bays."

While Lionel worked desperately hard, accepting every type of work, including writing and illustrating articles on a wide variety of subjects which interested him, Ethel racked her brains to think of some way in which she could help the family. She started a small farm at Buckholt—a smallholding would be a better description—keeping two

or three cows, goats, one or two pigs, besides chickens, ducks and geese, all of whose numbers increased because she was so reluctant to sell or eat their progeny. However, the fact that she was able to supply the family with unlimited quantities of butter, milk, cream and eggs proved of great benefit in her next venture. In 1922, while staying with the Dick Fosters at Cloutsham for the stag hunting, Lionel and Ethel met some friends who asked Ethel to take their two small children as paying guests when they themselves had to return to India. As Billy and Emma were much the same age as her two younger sons, Ethel agreed. Finding this an excellent way of improving the family finances, she took other children as well, so that for the next three years there were seldom fewer than five or six in the nursery at Buckholt. Ethel took her responsibilities very seriously and rarely felt able to go away with Lionel. One holiday, however, was sacrosanct. She, too, felt the spell of Exmoor and they went there every summer. While Dick Foster was alive they stayed at Cloutsham, the "Exmoor Farm" so lovingly described by Lionel in *Scarlet and Corduroy*. After Dick's tragic death they always went to the Dunkerny Hotel at Wootton Courtney, where from their bedroom window they could watch the deer on Robin Howe. Among the many people they met on these holidays were "A.J." and Mrs. Munnings and Cecil Aldin.

Two sad events which occurred in 1922 and 1923 were the deaths of Frank Wells, Ethel's youngest brother, from the tuberculosis from which he had always suffered, and the sudden death, from a heart attack while fishing, of Lionel's elder brother Arthur. Lionel missed him greatly, never forgot him, and when, during the Second World War, Lionel wrote *Scarlet and Corduroy*, dedicated it to him, and included several of Arthur's articles on fishing, thinking it would have pleased him to do so. Ethel's family had become sadly depleted. Both her parents were dead and of her four brothers only Willie remained, Philip having died of wounds at Etaples during the war and poor Gerald in an asylum, his mind having finally given way after Philip's death. Ethel's sisters, Cissie and Fanny, frequently stayed for long periods at Buckholt, Lionel as well as Ethel being very fond of both.

Among other guests who often stayed with us during the early 'twenties' perhaps the one I remember most clearly is Frank Wallace. He began to work with Lionel in 1919, sometimes writing articles which Lionel illustrated, sometimes, from his great knowledge of deer, helping Lionel with his own articles and sometimes just coming to

spend time painting with a brother artist. His great charm was partly due to his obvious enjoyment of life and his conviction, shared by Lionel, that every aspect of it was either amusing or interesting or both. He had travelled widely, read a great deal, met many distinguished people and written several books before he and Lionel produced between them *Hunting and Stalking the Deer*. Frank wrote the first part on stalking and Lionel the second on stag hunting and it was illustrated by both authors. Later Lionel and Ethel became acquainted with Elsie, Frank's wife, and quite understood why he always spoke of her with great affection and dedicated some of his books to her, calling her "his most lenient critic". But when he came to Buckholt, he usually came alone, since he came, as it were, 'on business'. He was very fond of children, insisting that we, and, I believe, his own children, should always call him by his Christian name. He stayed with us once during a very cold spring, when many small birds died. When the dead birds were found by the children, then aged about five or six, they were buried with great solemnity "so that they could go to heaven". The funerals were greatly increased in number by Frank, who collected every dead bird he could find, when out for a walk with Lionel, and brought them back for interment. One day, watching the lengthy proceedings with interest he asked, "Don't you ever say anything at your funerals?"

"No," replied one of the children in surprise. "Should we?"

"Oh yes," said Frank gravely. "You should say 'In the name of the Father and of the Son—and *into* the hole he goes'." This irreverance was received with enthusiasm except by the nursery governess who would not allow it to continue.

I was always glad when Frank came to Buckholt, enjoying his mischievous gaiety. He lent me books, usually on Scottish history, but now and then a novel which was banned and of which he had a copy. Once when Ethel protested that as I was only sixteen she was not sure that she wished me to read a banned book, Frank replied that no book which was beautifully written, as was the one in question, could possibly harm anyone. Both Lionel and Ethel agreed and my reading remained uncensored. One thing of which Frank professed to disapprove was my intention to teach in the state schools. Calling me "the pink 'un" and "our little Bolshevik", he would persuade me to defend my reasons and then demolish all my arguments with the greatest ease and rapidity, claiming that the working class neither

wanted nor needed education and that its members were, without doubt, both nicer and more useful without it. When, however, I went to College a few years later, he wrote to me regularly and amid all the unfamiliarities, difficulties and drabness of teaching in the often grim and unlovely elementary schools of the period, his letters were like a breath of fresh air from another world.

A very different but equally welcome visitor to Buckholt at that time was the late Captain Jack Gilbey. In an article in *Country Life* written shortly after Lionel's death he describes their first meeting at an exhibition of Lionel's pictures at The Sporting Gallery. "I found myself being greeted by a friendly man, who looked me straight in the face, gave me a warm handshake and at once put me at my ease. Thus began a friendship which was to last without interruption for forty-two years." During the forty-two years Captain Gilbey has written many articles about Lionel and his work, and had what must be one of the largest and best private collections of his pictures in existence.

In a letter to me in 1970, Captain Gilbey said: "The Wilton at Gallows Hill was the first of Lionel's work, which I bought in 1924. It is probably one of the best he did."

The late Captain Gilbey was at that time a noted shot and first class bridge player. At Buckholt, however, he was kind enough to play such games as 'Gin Rummy' and 'Racing Demon' every night after dinner with my eldest brother Derrick and myself. Ethel would join us, but never Lionel, who hated cards. At about ten o'clock our guest would suddenly announce that the next round must be the last. When Derrick or I pointed out that it was still quite early, he would say, "I know, but if I'm tired I can't say my prayers properly, can I?" Recognising its sincerity, with this, to us I am afraid rather surprising answer, we had to be content.

Of the many other people who visited us at this time, I remember little. I had a governess and was of an age when I spent most of my time in the schoolroom.

CHAPTER SIXTEEN

The twenties have often been called Lionel's halcyon years, and during this period he became the 'well-known sporting artist', as he was usually described by the press in their reports on his work. In 1927 he was elected a member of the Royal Institute of Painters in Water Colour, an honour he greatly valued although for much of his work he used dark paper, grey or brown, and a considerable amount of white paint, the use of which is frowned upon by true water-colourists.

I have the catalogue of the contents of his first important exhibition at The Sporting Gallery, which opened on 2nd May, 1925. Entitled *Hunting Sketches by Lionel Edwards, A.R.C.A.* it includes also advertisments for other work in which Lionel was or had been engaged. The first is for Eno's Fruit Salts. Under a small reproduction of a picture called "Hunting Problem No. 2" is written: "The proprietors of Eno's Fruit Salt will be pleased to send on request (while the limited edition lasts) a Portfolio of Eight Hunting Problems illustrated by Lionel Edwards, A.R.C.A." On the following page of the catalogue is a list of books, illustrated by Lionel and Published by Constable. They are *Songs and Verses* by Whyte Melville, *Scattered Scarlet* and *Galloping Shoes* by Will H. Ogilvie, and described as coming shortly, *Hunting the Fox* by Lord Willoughby de Broke, and *Hunting Songs* by Egerton Warburton.

Perhaps the most interesing of the advertisments is that of Soane and Smith Ltd., 462 Oxford Street, from which I quote: "Hunting Services by Soane and Smith Ltd. For Breakfast, Luncheon, Tea, Dessert, etc. From the Original Watercolours by Mr. Lionel Edwards, A.R.C.A. The most unique ever produced and the only ones existing that portray actual life and incidents of present day hunting. Every article is the production of Copelend Spode Works and is beautifully hand-painted and finished by the finest artists."

The subjects from which the designs were adapted were pictures of twelve hunts, each with an appropriate title such as "Full Cry", and "Stag at Bay". There were also twelve small sketches, rather amusingly called "Accessories of the Chase", of which two were "The Master" and "The Huntsman".

There are I believe, very few of these "Hunting Services" still in existence, the reason being that all the copper plates were lost when the ship in which they were being transported to America during the Second World War was sunk. The firm of Messrs. Soane and Smith is no longer in existence.

The pictures, of which there were one hundred and thirty in the exhibition, were a very varied collection. Some were the originals of a set of hunting pictures done for *The Illustrated Sporting and Dramatic News*, others the originals for illustrations for books and articles which included sketches or paintings of stag hunting, racing, coursing, the International Horse Show, one of a rodeo (aptly entitled "The Prairie Waltz") and numerous sketches and paintings of sport and polo in India, a country he had never visited. Prices ranged from four to thirty guineas.

The exhibition was to have been opened by the Duchess of Beaufort but, owing to illness, she was unable to do so and her place was taken by the Duke of Beaufort and his sister, Lady Blanche Douglas. I remember they asked me which was my favourite picture in the exhibition and were surprised when I said it was "The Waters of Lethe", which depicts a hunted stag drowning in a river. I was a very shy seventeen, too shy to explain that to me the peaceful head in the brown rippling waters, borne along to the song of the river, was the death of the stag in *The Story of a Red Deer* by the Hon. John Fortescue. Lionel had given it to me when I was five, because it was one of his favourite books, and it had become one of mine also.

The exhibition was a great success, and Lionel had enjoyed preparing for it, entailing as it did so much hunting and such a variety of subjects. In an article in *Country Life* of 2nd May, 1925, the writer says: "When I saw scenes and characters from hunts such poles apart as the Wilton, the Belvoir and the Cheshire, I was tempted to ask whether the artist had, in cold fact, hunted in every county in England. The answer was illuminating—forty-six packs of foxhounds, five of harriers, five of beagles, five of other hounds, two packs of bloodhounds and one drag." Incidentally, by the time Lionel had reached old age this number had been doubled.

Lionel had already painted several portraits and later in that year painted one for the Dowager Duchess of Beaufort of the late Duke in his car, with his dog on his knee, out with his hounds, with the present Duke carrying the horn. This picture was later published as a print. It was a posthumous portrait but, according to an article in *Horse and Hound* of 29th June, 1926, "the Duchess considers it the best portrait of her husband in existence." Lionel himself wrote of it in *Famous Foxhunters*: "Although my sketch was actually made after his death it is no artist's invention, for many a time I saw him as depicted."

In later years Lionel painted several posthumous portraits, but was always worried that he might not get a good likeness, since it meant so much to the person who had commissioned it.

He had now also become an illustrator of books, over eighty in all, ranging from children's stories such as the well-known *Moorland Mousie* by Golden Gorse, and those by the child authoress Moyra Charlton, to those on a great variety of subjects by such authors as A. G. Street, "Crascedo", "Sabretache", R. C. Lyle, B. W. Curling, E. T. McDermot, Will Ogilvie and many others.

He is perhaps best known however for books in which he either collaborated with Frank Wallace, such as *Hunting and Stalking the Deer*, or for the many for which he wrote the text himself, including *Famous Foxhunters, Sketches in Stable and Kennel, My Scottish Sketch Book* and my own favourite *Beasts of the Chase*.

Lionel fully recognised that his own writings, in the matter of style, leave much to be desired, and in his introduction to *My Scottish Sketch Book* asks that his readers should, "in the words of the immortal Jorrocks:

'Be to their faults a little blind,
And to their virtues ever kind.'"

CHAPTER SEVENTEEN

Lionel now led a life which, while exciting and pleasurable, was also exhausting. It meant constantly travelling and frequently staying with strangers, whose kind efforts to entertain him often meant late nights. These were usually followed either by long days hunting on other people's horses in a strange country, or long days spent standing at his easel either painting a landscape (often in the most inclement weather) or human, equine or canine subjects for portraits. All this he enjoyed, but the inevitable stress was, I am sure, partly responsible for the onset, in October, 1925, of an illness which was to plague him for the rest of his life. The many doctors he went to never discovered what it was, but because of the intense pain, gave him morphia and allowed him to take some with him when he was away from home. The attacks were sudden and violent, but did not last long and he seemed to suffer no ill effects afterwards. He tried not to let his hosts know how ill he felt, but often used to say how much kindness he received from people's servants. On one occasion he gave his gold watch to someone's butler who had sat up all night with him.

Lionel once wrote of artists as seen by the workng class: "A famous horse painter once said to me, 'We artists are neither fish, flesh, fowl nor good red herring, insomuch as we are treated by all classes as belonging to none.' This is quite true of the 'lower classes', whoever they may be (for I have never yet discovered)—anyway, the 'lower' classes, for want of a better word, consider the artist not one of themselves, though most emphatically not belonging to 'the toffs', to use another outdated word. The result is they talk to the artist in a way they would not to members of more respectable professions. One hears both sides of a question, usually a singularly one-sided view in both cases."

In the course of his work, Lionel had many conversations with grooms, butlers, chauffeurs, head lads and hunt servants, but he knew how to hold his tongue and never betrayed confidences.

We had no car at this time, both Lionel and Ethel much prefering to use the trap, for which we always had one horse which would go in harness, and for many years Lionel hired a car for long journeys from a Mr. Dawkins of Broughton. The latter was a splendid driver, whose car, known by us as "the Yellow Peril" had usually to be driven at great speed if it was to arrive at its destination in time, owing to Lionel's habit of taking 'short cuts' which inevitably added many miles to the journey.

While Lionel's mode of life now meant that he was seldom at home, Ethel had settled into one of happy vegetation at Buckholt. When my younger brothers went to their prep school, the children who had been paying guests left also, so that Ethel now had time to enjoy her farm, her horses and her garden. She never wanted to leave home except to go twice a year with Lionel to Exmoor to hunt with the Devon and Somerset Staghounds. They took their own horses, which added to Ethel's pleasure, and it was the riding over the lovely country which she really enjoyed, rather than the hunting. Chatting one day with A. J. Munnings at a meet, he said to Ethel and to his wife that if they wished to go stag hunting they should endeavour always to be in at the death, since that was what hunting was all about. But, while reluctantly agreeing with him, Ethel always took care to be as far away as possible when the end came.

One thing which Ethel absolutely refused to do was to go away with Lionel to stay with people for whom he was working. She maintained that as the visit was on business, wives were not expected to be included, and that if she was invited it was only out of politeness. This refusal to accompany Lionel on such visits was probably the cause of the only serious rift which ever occurred in their marriage. Lionel liked the company of women and was attractive to them, and it is not surprising that he should have become somewhat spoiled by the attentions and flattery of the fashionable ladies amongst whom he constantly found himself. He had become well known, was nearing fifty, and life at Buckholt on the increasingly rare occasions when he was at home was, to say the least, humdrum.

On one of his visits to Ireland, a sister of his host fell in love with him, and subsequently he with her. I never met her, but would think she was nice, and that though she was years younger than Lionel, they were both inspired by genuine passion. When, however, Lionel gave me a book she had given him, I remember the scorn I felt, thinking,

"If she thinks he likes *that* sort of book, she doesn't know him very well." When Lionel told Ethel of his feelings, she was very surprised, deeply hurt and extremely angry and for many months of that year life at Buckholt was most unhappy, especially, I think, for myself and my eldest brother Derrick, who was at home at the time. The climax came when I returned from a dance and told Ethel I had been asked when the divorce was to be. Ethel had not realised that others knew of the circumstances and, absolutely furious, decided at once that enough was enough. She told Lionel that he must choose, and that if he chose 'the other woman' she would go to friends in South Africa, taking the two younger boys with her. Derrick and I could choose which parent we would prefer to be with. Fortunately, we did not have to do so, for Lionel, knowing that Ethel always meant what she said, decided, almost immediately that he could not face life without her, and forthwith ended the attachment. But Ethel found it difficult to forgive and forget. Though, as far as I know, there were never any recriminations, it was a long time before life at Buckholt returned to normal.

If, afterwards, there were other women in Lionel's life, he never again allowed a relationship to affect his marriage.

BUCKHOLT.
WEST TYTHERLEY.
SALISBURY.

STATION · DEAN.
TEL. WEST TYTHERLEY.

Sunday. Oct. 7. 1945

My dear Mary..

Sorry I shall not have
time if I come to see you
this weekend. I am off again
on Tuesday to Tommy Cooke
Guisv Hall. Guisv Walpere.)
expect to be away about 10 days.
Then I shall have to come back
to finish my rather tiresome
Nall Cairns picture, which is due Nov 3.

[...]

Cheerio.
Yours ever
Dad —

Letter to Marjorie from Lionel Edwards, 1928.

When Lionel returned to Ireland he insisted that Ethel should accompany him, which she did, very reluctantly. As usual, however, being always interested in the people she met she ended up enjoying herself, and when, in 1929, General Sir Alexander Godley, at that time Governor of Gibraltar, asked them both to stay so that Lionel could paint, she looked forward to the visit. We already knew the Godleys, having met them at Tidworth, when he was G.O.C. Southern Command, and had also met them several times with the Apsleys. Lady Apsley was an old friend, for before her marriage she was a Miss Meakins, a stepdaughter of Herbert Johnson, who for many years was Master of the Hursley Hounds. When she became paralysed after a hunting accident, Lionel often used to go to see her and later illustrated her book *Bridleways through History*, published in 1936.

I had gone to College in September, 1928, and now wish very much that I had kept Lionel's letters, always cheerful and amusing (and usually with pen and ink illustrations somewhere) describing the people he met, the horses he had ridden and his adventures either on his painting expeditions or in the hunting field. But I did not keep them and the following accounts of their visit to Gibraltar are taken from his diary of 1929.

"*March 19th*
 Arrived Gibraltar 7.00 a.m. Went over galleries, Moorish prison and castle with Mr. Cameron, A.D.C.
March 20th
 Painted, with Mrs. Williams, Ethel and Lord Dumfries.
March 21st
 Royal Calpe Hunt. 12.00 noon. One hour and thirty minutes after a fox in cork woods. Saw lots of red and roe deer.

March 22nd
Painted on Gibraltar racecourse.
March 23rd
To Tangier. Should have stayed with the Consul-General, Mr. Hugh Gurney, but owing to overcrowding were put up instead by Admiral Sir Guy Gaunt.
March 24th
To church in Tangier, then by car to Cape Spartel—had a puncture.
March 25th
Pigsticking with Tangier Tent Club. Rode a horse of Mr. Gurney's—good, brave and slow. Killed two pigs. Ethel rode a dun, also of Gurney's.
March 26th
Returned to Gibraltar by Spanish boat.
March 27th
Royal Calpe Hunt at Duke of Kent's farm. Found several foxes, but no scent. Rode His Excellency's horse "Kate". Lost five pesetas out of pocket galloping down hill!
March 28th
Lunch with the Colonial Secretary.
March 29th
Church at Government House Chapel (Good Friday).
March 30th
Royal Calpe Hunt Point to Point Races.
March 31st
Clay Pigeon shooting on racecourse. To tea with Admiral Townsend.
April 1st
Left Gibraltar."

It was a happy and interesting visit for both Lionel and Ethel, the former writing: "A hunt in the open country was particularly beautiful, as usually the sea and the rock formed the background with a foreground of golden broom and a middle distance of white houses set among dark trees. From a hunting point of view I must confess I did not share the local preference for the open, as I liked the cork woods best, which were so full of unexpected glades and little farms." He made good use of his time, painting several water-colours of hunting, racing

and pigsticking, some of which were reproduced as prints. As for Ethel, she enjoyed particularly the informality which characterised their stay with Sir Guy Gaunt. "One never knew," she said, "what he was going to say or do next, but he was always kindly and good-humoured. He took a great deal of trouble to entertain us and took me for several excursions in the car." She used to recall how, when the Admiral's car entered an Arab village, children would appear from every direction in expectation of the sweets he always carried with him.

On returning to England Lionel spent the rest of that year and those of the following decade, working harder than ever. Like that of many others, his work was affected by the recession, and in 1932 he wrote to Denis Aldridge, one of his greatest friends, "I cannot afford to go on breeding horses—got too many two-legged foals—no more four-legged ones, thank you." And in a subsequent letter to Denis he says, "I am too broke to go to Exmoor this autumn, in fact so broke I am leaving my horses out at grass as long as possible, and if trade does not improve they will have to stay out during the winter." Nevertheless, a critic writing in the *Daily Telegraph* of 9th December, 1932, remarked "I cannot explain why this of all years should see a record number of books on foxhunting." Lionel wrote *Wiles of the Fox*, *Famous Foxhunters* and *My Hunting Sketchbook, Vol. II*, all of which were published in 1932, and in 1933, *Sketches in Stable and Kennel*. He afterwards had a most successful exhibition of the original pictures at the Sporting Gallery.

One of his more interesting commissions was that of decorating the Plaza Ballroom in Dublin, 1932, for the Irish Sweepstake. According to *The Sunday Times* of April 17th: "His scheme to provide the Derby atmosphere includes the painting of a frieze eight feet deep running round three sides of the hall and curving round over the stage where the drum was situated. The curve will serve conveniently for Tattenham Corner. The frieze will comprise all the leading episodes of Epsom racecourse on Derby Day—the paddock, the parade, the start, the race, Tattenham Corner, the finish, and unsaddling and preparing to weigh in."

I remember that Lionel was worried because it was a rush job, but the result appears to have been successful.

Throughout the thirties Lionel continued to paint hunting pictures and portraits, to exhibit at both the Royal Academy and the Royal Institute of Painters in Water Colours and to hold at intervals exhibitions at the Sporting Gallery.

These were, I think, busy and happy years. I had been lucky eough to be given a teaching post at our village school, which meant that I could live at home. This had many advantages, one of which was that Lionel kept a horse for me. We now had enough servants for Ethel to be able to entertain more frequently and to enjoy doing so. I never knew when I came home from school who I should find having tea at Buckholt—if they came to lunch I missed them except at weekends. Our guests came from every sort of background and if they liked them, both Ethel and Lionel were quite uncritical of either their morals or their manners.

When people brought their paintings or drawings for Lionel to criticise, we always knew, if we were present, exactly what he thought of their work. If he said, "Yes, very nice, very nice," we knew he considered them hopeless. If, however, he thought they had a degree of talent, he would pick up a piece of charcoal and draw all over their pictures, in an attempt to show them what was wrong. He was quite oblivious of the shocked expression on their faces at this cavalier treatment of what they had considered some of their best work.

Fitz having died in 1929, Lionel now had no brothers left, and of Ethel's immediate family, only her two sisters, Cissie and Fanny, now remained. As for my own brothers, Derrick found it hard to settle down, but eventually became a partner in a riding school near Nottingham. Lindsay and Kenneth, being determined from an early age to become farmers, were at Dauntsey's School, which at that time had a strong agricultural bias.

So the thirties passed, on the whole uneventfully, and only towards the end of the decade did anyone realise that Europe was slowly drifting into war.

CHAPTER NINETEEN

As far as I can remember, after Herbert Poelhau left us in 1914, we met no Germans until in August 1939 we once again had one staying with us, this time a girl. A cousin who had accepted a sudden invitation to go to America, asked if a German friend visiting her could come to us for the remainder of her time in England. Ethel, remembering Herbert, of whom she had been very fond, promptly agreed. Gunnhild was charming, intelligent and well-educated and spoke excellent English. I enjoyed riding with her every day. Although both her brothers were in the German army, she was not a Nazi and made no secret of the fact that her family and many others disliked and distrusted the Party. After Gunnhild had been with us for about a week, I left Buckholt, having promised to go to an Oxford Group camp in Essex. At the last minute a friend rang up to say that as she, through illness, could not go herself, would I take a German girl with me who had come to England especially for the purpose of attending the camp? I picked up Madeleine in my Baby Austin in Winchester and during the journey managed to converse after a fashion, although her English was elementary, and my German non-existent. She was a very different person from Gunnhild. Now seventeen, she had been in the Hitler Youth Movement since she was seven. She did not think it would be wrong for Germany to invade Poland, for if the Führer thought it was right to do so it must be, for he never made mistakes. She had obviously been taught that the Jews were sub-human and not worth consideration. When I pointed out that Jesus was a Jew, she said that that was different.

We were at the camp for only a few days before war was declared. Madeleine received a telegram from her parents, telling her to return to Germany immediately. I received one from Lionel and one from my friend in Winchester, both urging me to try to return with Madeleine in time for her to be put on a German ship before such sailings were

stopped. That night Madeleine arrived in my tent, which I shared with a friend, hysterical with terror. Between her sobs we understood that the Führer would bomb England out of existence this very night. She also insisted that the lights of the cars we could see in the distance were those of lorries filled with German troops who had already invaded the country. In the morning, finding ourselves still alive and her English friends comparatively unperturbed, Madeleine regained her cheerfulness. In fact, on our way home through Windsor she wished to visit the castle. I refused, but she insisted on stopping to buy photographs of Princess Elizabeth and Princess Margaret. Both Madeleine and Gunnhild were returned safely to Germany and both girls survived the War. When however, Gunnhild wrote to us after the War I am sorry to say that by then we so disliked anything and anyone German that we did not reply.

When I reached Buckholt I found that already life was changing. Lindsay and Kenneth, who were 'Terriers' had been called up and had left home, so the farm was being run by Lionel and Ethel, helped by landgirls. Derrick, who had been in the Army for a short time, and was on the Reserve, knew he would be called up and was preparing to sell his Riding School, if it was possible to do so in such uncertain times. I would have liked to join the W.R.N.S. but teaching was a reserved occupation so that instead I had to help to cope with the influx of evacuees, shortage of staff, and in a small country school, large classes in overcrowded classrooms. We had three young evacuees at Buckholt. Most of the children were, on the whole, very well-behaved considering that in contrast to the slums from which many of them had come, life in the countryside was as strange to them as if they had been dropped into it from another planet. Perhaps it was natural that most had drifted back into their blitzed towns long before the end of the War.

Lionel was, not surprisingly, finding work increasingly difficult to come by, and knowing his restless spirit, it was a great relief to his family when he was asked to form a unit of the Home Guard. It was to be a mounted unit, so we were able to keep our horses, and it was a job for which, with his intimate knowledge of the woods, fields and downlands for many miles around Buckholt, he was eminently suited. As was his custom, he took his work extremely seriously, and was, I should think, as efficient as it was possible to be in such circumstances. His recruits were neighbouring farmers and their employees together with one or two elderly gentlemen who had evacuated themselves from

Southampton or Portsmouth. Trying to teach them to become 'mounted' was sometimes hilarious, but not such a shock as Lionel received when he observed the old shepherd peering down the barrel of his loaded rifle, presumably to see if the bullet was in the right place.

In a letter to Denis Aldridge on Old Year's night, 1939, Lionel mentions his continued efforts to find work. "I want some ideas for wartime articles for *Country Life*. I've done 'Hunting and the War' and 'The Women's Land Army' and now my invention has failed." In fact Lionel continued to write and illustrate articles for *Country Life* throughout the War, Denis supplying some of the ideas as Lionel had hoped. In the same letter, Lionel says, "Ted Seago rang up yesterday en route to France on a camouflage job. The young artists are doing well, but the old 'uns have to 'Dig for Victory' and a damned dull job it is." Ted Seago, who was based for a time at Southern Command Headquarters at Wilton often came over to Buckholt and we always enjoyed the visits of this brilliant artist and strange, interesting man.

The winter of 1940 was one of the coldest I can remember and one which, for various reasons, I shall never forget. Lindsay and Kenneth were now both at Aldershot and in the O.C.T.U. (Officer Cadet Training Unit) but when Kenneth got pneumonia for the third time, which affected his heart, he was released from military service and sent home to engage in 'agricultural duties' which enabled him to take over the running of the farm. Then Lindsay, who had been in hospital with what was thought to be a bad attack of influenza, was also sent home, to recuperate. One night however, he suddenly developed a very high temperature, was in great pain, and became completely paralysed. It was during the worst of the weather and we could hear, as we sat up with him, the crackle and crash of falling trees as they were brought down by the weight of the frozen snow on their branches. There was no telephone and when we managed finally to contact our doctor in Salisbury the following day, he had to be brought most of the way by tractor. As it was impossible to reach the Military Hospital at Tidworth, an ambulance was at last obtained from Salisbury and helped by tractors, managed to reach Buckholt and return with Lindsay, Lioned and Ethel. Lindsay was taken to the Salisbury Hospital and Lionel and Ethel stayed at the Old George Hotel (now the Bay Tree Restaurant) while, for a fortnight, Lindsay's life hung in the balance. Also staying at the Old George was the late Lord Knutsford, who was at that time working at Southern Command Headquarters at Wilton, and

Ethel and Lionel always remembered his kindness in joining them every evening to try and cheer them up with his fund of hunting anecdotes and amusing stories. It has never been satisfactorily decided as to what Lindsay's illness was, but it is thought it was probably some form of meningitis. He gradually recovered, but was on crutches for many months. When finally he had sufficiently recovered he was sent back to Aldershot to go before an Army Medical Board, which discharged him and he returned to Buckholt to join Kenneth on the farm. Both joined Lionel's company of the Home Guard, which now numbered ten.

During the summer of 1942 Derrick married Audrey Weston, who he had met at his riding school. In the autumn his regiment was sent to India. Now a Major, he was transferred to the Royal Indian Army Service Corps after which he was given the job of running a huge cattle farm in Assam, which was to provide meat for the Fourteenth Army. It was a lonely and sometimes dangerous job, but for once the Army had succeeded in putting a round peg in a round hole. Derrick did extremely well and was mentioned in despatches, a fact of which characteristically he never told us and which we only found out by accident.

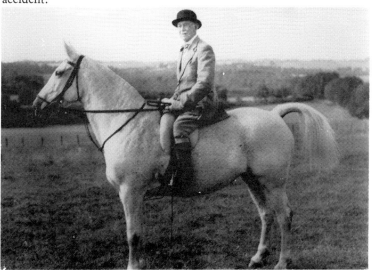

Lionel Edwards on a grey mare.

One person who might almost be said to have enjoyed the War was Ethel. Lionel was at home most of the time, so was the rest of her family except Derrick. When Lindsay and Kenneth had returned to take over the farm, she was able to enjoy it without responsibility for its efficiency, and best of all, there were no formal social obligations to fulfil which she so hated. But she enjoyed it when people came to Buckholt and both she and Lionel liked the American officers who, later on, were stationed near us.

Lionel remarked in *Scarlet and Corduroy* published by Eyre and Spottiswood in 1941 that "As a countryman I must admit that living in a remote spot the War has not been such a terrific interruption of normal existence as it has been for those in the towns." His Home Guard duties had become routine and he was able to resume his writing and painting. The contents of *Scarlet and Corduroy* are, as Lionel says in its preface, "reminiscences of sport and farming by one who has been lucky enough to see quite a lot of both in various places, and like Dobson's gentleman of 'that past Georgian day has overlaid his toil with pleasure'." The book also contains articles on fishing by his favourite brother Arthur, and is dedicated to the memory of that "impecunious gentleman who loved salmon fishing and helping lame dogs over stiles, both expensive pursuits."

It would seem that by 1943 many people had decided that the eventual defeat of Germany and her allies was certain and that therefore the future was to some extent predictable. For some life would never be the same again, but for other luckier ones it was beginning to return to normal. Lionel's work returned with a rush and he wrote to Denis Aldridge that he was "bunged up with books to illustrate. After having damned all to do for so long, it's quite cheering." He had, in fact, already begun his *Reminiscences of a Sporting Artist*, illustrated several small books, including one by the local village schoolmaster, entitled *Our Food from Farm to Table*, and continued more or less regularly to write and illustrate articles for *Country Life*. Now, however, the work became more varied. He not only painted a few portraits but was commissioned to paint hunting pictures which meant once again hunting with different packs. He found the gloomy prognostications he had made regarding post-war hunting were, happily, unlikely to be fulfilled. One such ran as follows: "Hunting after the War will be a rum show. No one will want to go to the Shires now it is nearly all arable. One hunt, to anticipate this, has decided to breed a bigger, slower hound, as with increased wire and arable the chase will be slower. The theory is all right, but foxes will not oblige by going slower and young people will not go out to see a fox walked to death."

An unusual variation with which Lionel amused himself for a short time was working on smoked plates. During the twenties he had done a set of fourteen for a friend, Mr. W. Savill. Having obtained some plain white plates with a good glaze, one was held over a candle until the whole of the centre was blackened. Lionel then drew on it some small design—a horse's head, or a hound, perhaps—with a sharpened matchstick, fixing it afterwards with charcoal fixer. The result was effective but the plates had to be for ornament only, since they could not be washed in hot water.

In the autumn of 1943 Lionel went with "Dalesman" (Mr. de Courcy-Parry) on what he called a Sponge's Sporting Tour of John Peel's country, before writing a series of articles for *Country Life*. They stayed with different farmers who all gave them a warm welcome, but, as Lionel said afterwards they all had one thing in common, "a dreadful thirst, I simply couldn't compete."

Several years later, when Lionel wished to paint the wild cattle at Dynevor, "Dalesman" asked both him and Ethel to stay and both very much enjoyed their visit and sharing his unconventional way of living.

From almost the beginning of his artistic career Lionel had at various times been commissioned to paint racehorses. During the twenties he had done a set for reproduction as prints for *The Illustrated Sporting and Dramatic News*, which included "The Tetrach", "Epinard", and "Sansovino". He also painted racing itself, enjoying the challenge of portraying swift movement, at which he considered Gilbert Holiday to have been the expert. National Hunt racing interested him, but flat racing not at all. However, after illustrating *Brown Jack* and *The Aga Khan's Horses*, Lionel suggested to R. C. L. Lyle, the racing correspondent of *The Times*, that the latter should write a book on Newmarket. Mr. Lyle wrote in the foreword, "This history of 'Royal Newmarket' is entirely due to Mr. Lionel Edwards. He suggested the subject and himself supplied much of the material for the text." It was undoubtedly the history which interested Lionel, not the racing. The book was due to appear in 1940, but its publication was postponed owing to war conditions until 1945. In the meantime Mr. Lyle had died, and the book was finished by Mr. Adair Dighton who wrote the chapter on George VI for which, in 1944, Lionel painted the King's horses, "Big Game", "Sun Chariot" and her foal, and "Fair Glint". In 1944 Lionel also painted "Lady Electra", "Pamphilos" and "Herald", trained at Malton by Mr. Philip Bull, and in 1949 notes in his diary that he is off to Newmarket to paint "Owen Tudor", "the second Derby winner I've painted this month."

A book by B. W. R. Curling ("Hotspur" of the *Daily Telegraph*) entitled *British Racehorses* was illustrated by Lionel and published in 1951. There are plates in colour of twelve famous racecourses, each of which, of course, Lionel had to visit. These visits usually meant an enjoyable outing for the family. Both Lionel and Ethel liked motoring because of the opportunities it gave of seeing the countryside. As they always started later than they had intended they travelled fast, but this

was not the only hazard endured by their driver. Lionel sat in front, next to the driver, and many is the time I have seen poor Rogers, the chauffeur, while we were travelling at high speed, trying to duck under, or peer over, Lionel's outstretched arm, as the latter pointed out to Ethel, sitting in the back, some piece of country where he had had a really good hunt. Not surprisingly, they were sometimes involved in minor accidents, and from these they always emerged, not only unscathed but completely unperturbed.

On one occasion when Lionel wished to paint at Cheltenham racecourse before Arkle was to race there, it happened that we had friends staying at Buckholt who kindly offered to take him in the car. On arrival his chauffeuse suggested that he should paint a jump on the far side of the course. Lionel demurred, saying that the jump was very difficult to reach carrying all his artist's materials. "Oh," said his chauffeuse, "that's easy. I'll just drive across the course," and without more ado, she did so, ignoring vigorous protests from Lionel and her husband. The ground was soft and there was a big race the following day. In a few moments an official arrived, almost speechless with fury. When the storm broke, Lionel and her husband sat in ungallant silence, Lionel merely remarking as they were escorted back, "Well, we did tell you."

Towards the end of 1944, No. 3 Platoon of the 10th Hampshire Home Guard had begun to demobilise itself in order to spend more time working on the farms. Over and over again Lionel noted in his diary "No one on parade". In December the platoon was formally disbanded and on 1st January, 1945, a small party was held at Buckholt to celebrate the event. It was held in the schoolroom where all the lectures and meetings had taken place. The room was small and cosy, and although we all spent much of our time there, nothing had been altered since childhood days, and the long shelves which lined the walls were still filled with children's books. These included the famous *What Katy Did* books, and on this occasion one of our guests said to me: "*Do* tell me, I've so often wondered during lectures, what *did* Katy do next?"

When V.E. Day came, Lionel was painting at Exford when he heard the news, while Ethel and I were in Wales, in a little slow train which stopped at every station. Also on the train were a great number of black American troops, who, when they heard the news, got out at the next station and sang and danced on the platform for so long that at last the guard had to plead with them to get back on the train so that it could continue on its journey.

To return to family matters, on the 23rd May, 1945, Lindsay married Claire Townsend-Rose and left home to become farm manager on a neighbouring estate. Later on Derrick returned from India and rejoining his wife and son at Nottingham went into his father-in-law's business. In June of the same year the Norman Court Estate was sold and Lionel bought Buckholt. To be able to do so was a great relief to Ethel, who had never lost her fear that for some reason or another our tenancy might be terminated. She had grown to love the old house as much as she had loved Benarth, and its acquisition was a source of great happiness to both. Although Buckholt was often very cold and in many

ways extremely inconvenient, it never occurred to either of them to
make any alterations and they settled down to live in it contentedly for
the rest of their lives.

Lionel continued to paint his usual subjects, hunting countries,
racehorses, Arab stallions, military parades, coaching scenes, which he
loved to paint, and portraits.

The latter included one of an American couple who wished to be
portrayed at a meet of a famous pack which they did not attend, and of
which hunt they were not members. Lionel, amused, did as requested.
He also painted a picture which the Pytchley presented to H.R.H.
Princess Elizabeth on her eighteenth birthday. It met with royal
approbation and was, I believe, subsequently reproduced as a
Christmas card. It was of H.R.H.'s first, and the great huntsman of the
Pytchley's last, hunt and in fact it is Freeman and his hounds which
dominate the picture.

In the autumn, after an illness from which he took a long time to
recover, Lionel wrote in his diary a quotation from John Buchan.
"Suddenly I realised I was getting old and had left many good things
behind me." He was now making a fair amount of money, but so long

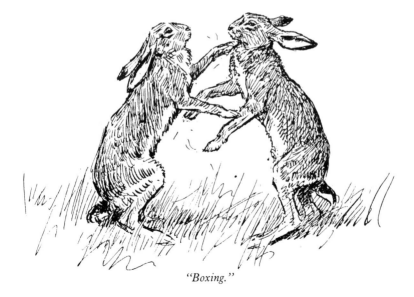

"Boxing."

as there was enough for his needs, it meant nothing to him. He was completely devoid of conceit as regards his art, and never expected high prices for his work. In his diary for 1946 he notes wryly, "Two of my pictures, dated 1925, sold at Sotheby's for £24.00 and £25.00 respectively. The latter double its original price, the former one pound less."

Lionel was always ready to help any aspiring artists who asked for criticism and advice, and many did, including Eric Meade-King, John King and Denis Aldridge, but he always steadfastly resisted any attempt on the part of anyone to become his pupil. He did not wish to teach, believing he had no aptitude in that direction, and thought, as did Ethel, that his long and frequent absences from home would be very unfair on anyone who paid for tuition. Nevertheless, in 1947 he acquired (and that is, I think, the relevant word) his one and only pupil, and Peter Biegel has very kindly agreed to write his own account of how he came to know and subsequently to work with "the Maestro", as he always called L.E.

CHAPTER TWENTY-TWO

My first contact with L.E. was when as a boy at my prep. school I wrote to him, with all the naivete of youth, a letter of admiration and asked for a sketch. Back came one of a horseman in hunting clothes on a sheet of notepaper bearing the printed address Sennowe Park, Norfolk, where he was at the time painting a portrait. Underneath the signed sketch is written: "Come and see my sketches at 32 King Street, Covent Garden, in December." The ink is badly faded now, the sketch having been promptly framed and hung in my bedroom, wherever I was living at the time, until the outbreak of the Second World War, when for safety I took it out of its frame and packed it away for safe keeping.

Towards the end of my public school days I wrote to him again, enclosing a few sketches and asking for his criticism and advice. Again a letter, almost by return of post. The criticism and advice contained a note of encouragement, and on being asked by my father what I intended to do when I left school, I promptly replied that I wanted nothing else than to be a sporting artist and to apply to Lionel Edwards in the hope that he might take me on as a pupil. However this was not to be for some fifteen years. These two incidents well illustrate Lionel Edward's extraordinary kindness and helpfulness to anybody and everybody who approached him. He was himself extremely humble about his work and quite without any jealousy towards his rivals. He would be equally scathing in his criticism of a bad picture as he would be generous in his praise of a good one, whoever the artist might be. He has said in one of his books that he thought his 'brothers of the brush' took themselves far too seriously, and in fact valued his own work very little, always looking critically at whatever he had done and believing that he could have done it better.

My first meeting with Lionel Edwards I well remember. It was just after the War and I had to go to London to attend a medical board, being

still in the Army. I had been sent a Railway Warrant and worked out
that if I caught the one o'clock from Salisbury I could get there in good
time. I lived at home in Tollard Royal and my loving mother had made
me up a small packet of sandwiches, saying, "You won't get anything
on the train, and this will keep the wolf from the door until you get to
Waterloo." Being in good time for the train, I was sitting on a bench
just about where I reckoned a 1st Class coach would stop. One of the
people walking up and down the platform intrigued me—a tall, thin
man wearing a bowler hat with a ring in the back of it, and with a
leather briefcase slung across his shoulders. He was a hunting man,
obviously, but what did he do for a living? It was the day before the
National Hunt festival at Cheltenham, and I put him down as a racing
correspondent. At last the train arrived and I helped him in with his
large bag. He was very fussed and asked all the staff he could find if
there was a restaurant car on the train. Eventually he was told by the
guard that there was not. It was still virtually wartime and there were no
other facilities on the train. I told him I had a small packet of
sandwiches which he was welcome to share. We sat opposite each other
in corner seats in an empty carriage. The stranger evidently felt it
behoved him to start a conversation, which he did by showing me his
new socks, which, he said, had only been washed once and were now
just up to his ankles! Also due to wartime difficulties, he said, was the
fact that some new sable paintbrushes which he had bought, only lasted
for one picture, after which they had lost nearly all their hair. At this I
pricked up my ears and said, "You are an artist, then, Sir? May I ask
what is your subject?"

"Landscapes and sporting subjects," he replied.

This set my brain racing. I did not think it was "Snaffles" for he
would have gone from Tisbury. Could it possibly be my long-time hero
Lionel Edwards? I found that it was. Poor man! I never stopped once on
the way to London, asking him how he did this and that and those
fantastic skies, and telling him how I'd had the nerve to write to him
from prep. and public school, sending with the letters some sketches to
criticize. I remembered, I told him, that he had said I must learn to
draw figures. Before we reached Woking he had agreed to my coming
over to show him some of my stuff one Sunday when he got home. I
eventually apologised for my rudeness, to which he replied, "Don't
worry. I'd have done the same in your case."

In due course I was rung up and told to come over the following

Sunday with some of my stuff. The first sight of the studio was heaven and I went round the walls talking to him about every sketch and picture I saw.

It did not take long to fix up terms for me to be with him for the summer. If he went away to do commissions, I would be prepared to do whatever he set me and he would criticize it on his return. He was very apologetic that he could not have me to stay at Buckholt, but he thought he could arrange for me to stay at The Black Horse, just a mile away in the village. As I had a little car, an Austin Seven, I could pop up and down quite easily. In the meantime I was to put in a term at the Bournemouth School of Art, concentrating on learning to draw figures.

My first morning at Buckholt was, I realised afterwards, by way of seeing what I was made of. It was a boiling hot day. I tied up a big home-bred mare called "Jennifer" outside in the yard and set up my easel. L.E. then appeared with a $30'' \times 20''$ canvas which he set up next to me, and slightly behind so that he could see what I was doing. I started laboriously drawing in charcoal. "Get that hind leg finished and the background in before you go any further. Get the paints out. Come along. Get a move on. We've got to develop speed in you." All the while he was painting himself, quickly and boldly, a brilliant portrait. In the evening, it being a little cooler, with the help of his two sons, Lindsay and Kenneth, we fixed up a simple plough, and worked on it side by side, he sitting on a bale of straw and I on an upturned bucket. I got back to my digs abour 8 o'clock, tired out!

I kept a diary, which I wrote up every evening after supper, and looking through it I find quotations from him such as: "Use your brains, my lad. You are lazy. You don't think things out. You've got to think when you are painting a picture." I was never allowed to get away with anything, but was criticized unmercifully. "That horse is lame in front," "This horse has a broken hind leg. Go and get the pony out and paint it from life." This lesson of attention to detail was brought home to me one very hot summer afternoon. I was asked by L.E., or "the Maestro" as I always called him, whether I would pose for him. He had a picture to do of a whipper-in halloing a fox away. I found myself in a very thick, pink hunting coat, half-turned in the saddle, holding my cap up. He became absorbed in his work, so I had to sing out when I could bear it no longer. We had a break for lunch and then for tea, and finally the ordeal was over. It was a fantastic picture, the pose perfect. The next morning I was in the studio early to have a good look at the

picture. To my surprise it was no longer there. When "the Maestro" came in he said, "I'm afraid you'll have to pose again. Looking at it before breakfast I realised the horse was too near the centre of the canvas." I could scarcely believe it, but this was Lionel Edwards. If it wasn't right it just had to be done again. A very salutary lesson, hardly learned.

Sometimes when I arrived after breakfast, if there had been a reasonable weather forecast, I would be despatched to the kitchen to ask "the Missus" for some 'sammies' and we would set off in my little car loaded with painting gear, for Exmoor. Frequently when we got there it would be pouring with rain, but nothing deterred L.E., and we would sit with the windows open looking at what I would think a quite hopeless prospect, just a wet road with big puddles and trees blowing in the wind. When next I looked at his picture it would show the Devon and Somerset Staghounds returning to kennels, or some such subject.

Winter came and with it the end of my agreed time with L.E., but I stayed on, learning my trade and hunting. He was marvellous about the latter. Whenever he looked like being away for some time he would go through the fixture list of the Hursley Hunt with me, working out how we could get the most hunting out of the two horses. He, of course, knew the country like the back of his hand, and from frequently accompanying him, I learnt all the short cuts and jumping places.

The day before my time at Buckholt finally ended, "the Maestro" and "the Missus" went away to stay with friends. He was to paint a Champion Hereford bull and also to hunt. I helped him pack—sort out paints, etc. He was in great form and delighted as a small child at the prospect of a hunt. Just before he left he said, "I shouldn't be much use to you anyway after this month—I shall be away so much, but you are so near you can always pop over if you get stuck. Just ring up to see if I'm here, and have a refresher course for a week or two." I thanked him for everything.

By the time Peter left us he had become one of the family, and a very helpful member, always ready to do any odd jobs, most of which had nothing whatever to do with art, and to drive Lionel about in his little car. After his marriage he and Dora were frequent visitors to Buckholt.

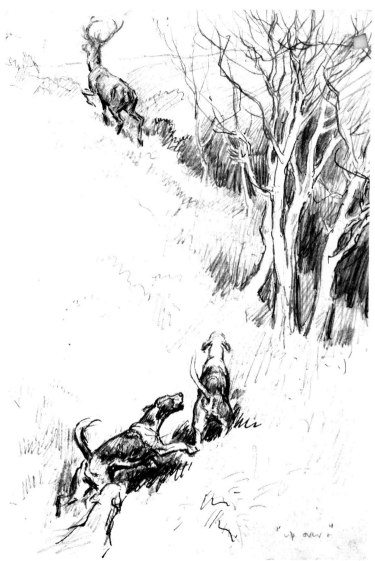

Devon and Somerset Stag hounds, "up over".

During the late forties and throughout the fifties, family life at Buckholt was for the most part uneventful, except for one sad and important happening. In 1947, while on holiday in Scotland, Lindsay's wife, Claire, caught polio, and was desperately ill for many months. In April, 1948, she had a relapse, but afterwards made a slow, courageous partial recovery. Their two very small boys stayed with Claire's parents and everyone did their best to help, but it was a very difficult time for Lindsay. Fortunately, in due course, Claire was able to return home to lead again a more or less normal life. Later on they moved to Frenchmoor Farm, which is only about three miles from Buckholt, and Lindsay started farming on his own.

Derrick continued to live near Nottingham for some time, then, with his family of four children, moved to Lincolnshire, where he remained for the rest of his life.

Kenneth, my youngest brother, married Nancy Harrison, and since Newman's Barn Farm, which Lionel bought for him, had no farmhouse, they lived at West Dean for five years before coming to Buckholt to share the house with us.

In 1949 Ethel and I went to Norway. We enjoyed ourselves, but when we went up into the mountains the altitude affected Ethel's heart. From then on she felt unwell and was looking forward to returning home. It was a shock, therefore, when having spent all the small amount of money we had been allowed to take with us, we discovered that our travel company had omitted to book our return journey on the *Venus*. Fortunately we managed to borrow enough money to fly home from Stavanger in what must have been one of the oldest planes surviving from the War. Besides being thunderously noisy, it oozed oil from every possible part of its structure, and smelt abominable. Ethel, however, who had never flown before, seemed quite unworried, and took it all in her stride.

In 1948 Lionel was seventy, but his age in no way inhibited his enthusiasm for a full life, or diminished his prolific output. He quoted in his diary for that year a passage from John Buchan's *Blanket of the Dark*: "There is a new world coming to birth, good sirs, though men know it not and crave rather to have an older world restored."

Although interested in the coming of a new world, especially as it affected sport and art, there is no doubt he would certainly have preferred "to have an older world restored." When Sir Alfred Munnings, the retiring president of the Royal Academy, spoke at the Burlington House banquet, and roundly trounced the moderns in art as "daubers . . . who cannot paint a tree to look like a tree," Lionel wrote, "Well done A.J. I was delighted to see you had a crack at them. The fault is not so much the young artists as the critics whose words these foolish youngsters take for gospel." Lionel also criticized some well-known artists who, he felt, followed the current fashion because it was easier and more profitable to do so than to struggle to give of their best in more traditional styles.

The *Reminiscences of a Sporting Artist* was first published by Putnams in 1947. Much of it was written during the War when Lionel had more time on his hands, and it is written in a pleasant, unhurried reflective style. The review I liked best is that written by the late Major Guy Paget for *Country Life*, in which he says of the reminiscences that "they are well-designed, simply set out and as clearly drawn as are his pictures. Modesty and humour are their hallmark." Major Paget then recalls a story (not in the book) of a night Lionel spent at Sulby, in a bedroom haunted by bats. He killed several with a towel, but was very surprised on coming up to dress for dinner the next evening, to find his victims arranged on his dressing table. On enquiry, the housemaid explained that as he was a 'hartist' she thought he collected funny things. Lionel told this story himself, after dinner that night.

Of other books written and illustrated by Lionel during this period, my favourite is *Beast of the Chase*, exhibiting as it does his ability to paint many different animals. He also wrote and illustrated two books on favourite subjects, *The Fox*, published in 1949, and *Thy Servant the Horse*, published in 1951. The latter describes every form of horse transport from Roman chariots and packhorses, troop horses and carthorses, to coaches and carriages, all with their appropriate horse furniture. He always found great pleasure in depicting horse drawn vehicles and harness.

The books for which Lionel supplied the illustrations at this time are too numerous to mention, but included *British Racecourses* by B. W. R. Curling ("Hotspur" of the *Daily Telegraph*) and a book called *They Met at Eleven*, for which Lionel wrote the Introduction. It was by Frank Meads, the ex-postman and well-known hunting photographer for whose work Lionel had a great admiration, not only for the excellence of the photography but because, pictorially, the composition of the photographs made them works of art in themselves.

An American asked Lionel not only to illustrate the book of Scottish songs he had composed but also to paint a Scottish landscape containing as many of the native fauna as possible. Lionel managed to include a golden eagle, blackcock, a red deer, a fox and a hare!

Another American client of Lionel's and a very good customer, was a Mrs. B. from Pennsylvania. On one of her infrequent visits to England she bought a picture of Lionel's from Roland Ward's Gallery. After returning to the States she continued to buy his pictures by telephone, requiring an exact description of every painting. Eventually, wishing to speak to Lionel himself, she obtained our telephone number. After this she would ring up sometimes twice in a week to talk for an hour or more. Lionel found this so time-consuming that he soon pleaded deafness (he had become slightly deaf) and handed her over to one of us, usually Kenneth or myself. Our conversations ranged from gardening and farmwork to art and politics and domestic problems on both sides of the Atlantic. Her telephone bill must have been enormous, but she was obviously very lonely. She told us that after her parents died she continued to live in their large house with only the old butler for company. She was very nervous of burglars and if anyone loitered too long in the road beside the house, she would call to them from her bedroom window to go away. If they did not do so she would fire at them with live ammunition. She said that to use blanks in the States was a waste of time.

Lionel sometimes found the behaviours of his English clients also surprising. There was the lady who was already standing on the steps outside her front door when Lionel arrived to stay. As she shook hands she said, "This is how-do-you-do and goodbye. I've decided to leave my husband and this seems as good a time as any. The butler will look after you." Then there was the second wife who at dinner sat immediately beneath Lionel's portrait of her strikingly beautiful predecessor. "Comparisons were inevitable," said Lionel afterwards. "Why could

she not have sat at the other end of the table?" Staying with an M.F.H. who was a widower with an only daughter still at school, Lionel found his host so incapably drunk by the end of dinner that there was nothing for him to do but to go to bed with a book. On returning a year later, however, Lionel found his host had, with courage and determination, given up drinking altogether when his daughter had refused to have her coming-out dance at home because she was so ashamed of him. There was also the butler, who Lionel had met before in a ducal house, who apologised in front of Lionel's host and hostess for their inadequancy in looking after him during his visit. "It's not their fault," said the butler, "they just don't know any better."

Of the many portraits both human and equine which Lionel painted during this period, perhaps some of the most interesting were those of Col. Harry Llewellyn on "Foxhunter" and those of racehorses including Miss Dorothy Paget's "Straight Deal" and the King's horses, "Fair Glint", "Sun Chariot" and "Big Game". When he painted "Owen Tudor" he remarked in his diary: "This is the second Derby winner I have painted this month."

Throughout his seventies, Lionel continued to hunt with whichever pack he was to paint and seemed to enjoy his hunting as much as ever. He always mentioned in his diary a description of the horse he had been lent and its performance. Of one he wrote, "Rode a dun cob of the Master's. Jumped three wire fences for a start," and of another, "Rode a grey mare of C's, a good performer, but we had a fall in wire. Not her fault."

Lionel was on the Hunt Committee of the Hursley for many years and took the greatest interest in all its affairs, particularly, perhaps, with the putting up of hunt jumps, as the country became progressively more difficult to hunt owing to wire. He hunted regularly when he was at home, but in 1953 he fell fifteen feet off a ladder, and was not allowed to ride for some time. He wrote to Peter Biegel from Salisbury Hospital that his only joy was in talking to a pretty nurse who came from Exmoor. "We have terrific talks about stag hunting." Later on, not being able to ride his own mare for some time, he went hunting on Dapple, the grandchildren's pony. She was only about eleven or twelve hands and he sometimes asked too much of her. She evidently came to this conclusion herself, for on one occasion she put him off and came home without him.

Although he always took it very seriously, Lionel found that hunting

with his local pack had its amusing side. After a very wet day he wrote in his diary: "Hounds ran in a circle. Quite a lot of damage to J's grass. Serve him right for insisting on hunting over L's farm when the land was water-logged! We had words on the subject. Two Chairmen at war! Very awkward for the M.F.H."

In 1951 Lionel held a one-man exhibition of forty-three pictures at Rowland Ward's, and in May, 1953—Coronation Year—another, also at Rowland Ward's, comprising about thirty pictures which included an oil of "The Royal Mews" and a study of the Pytchley at Crick village. In December of the same year the Duke of Beaufort opened The Bristol Field Sports Society's fox-hunting exhibition, at which were shown "The Crick Meet of the Pytchley Hounds, 1852", by Henry Barraud, and Lionel's painting "The Crick Meet, 1952" which had been commissioned by the Pytchley Hunt as a companion to the Barraud group. As in Barraud's picture, many of the figures in Lionel's painting were portraits. Stanley Barker rides behind his hounds, followed by the Joint Masters, Col. J. G. Lowther and his son Captain G. H. Lowther, and on the right a former Master, Major R. Macdonald-Buchanan.

In October, 1955, Ethel and Lionel celebrated their Golden Wedding. It was agreed that what both would most enjoy would be a visit to Exmoor, where Ethel, who loved motoring, could be driven about the moor, and both could re-visit old haunts. So we all, Derrick and Audrey, Lindsay and Claire, Kenneth and Nancy and I went to stay at The Dunkery Hotel at Wooton Courtney, where once again Lionel and Ethel were given their favourite bedroom overlooking Dunkery and Robin Howe. At their request, nothing had been said about the Golden Wedding, but somehow the staff at the hotel found out. They made special preparations and their kindness and good humour made it all much more enjoyable. In the evening we went to Webbers Post, hoping to hear the stags roaring, but in this we were unlucky.

On 9th November Lionel celebrated his seventy-seventh birthday, and on the 23rd saw the opening of his one-man show at Rowland Ward's, of which the critic for *The Field* said, "He has staged what many believe to be the best one-man show he has ever given."

On 9th November, 1958, Lionel was eighty. He had had a satisfactory year. Although the doctors had discovered belatedly that he had only one kidney, his health was good. He had hunted regularly with the Hursley on his old mare, had continued to paint out of doors in all weathers and in fact did so much work that he was able to put thirty-four new pictures as well as borrowed ones, into the exhibition at Rowland Ward's Gallery. It was opened on 25th November by the Duke of Beaufort, who had opened one of his first shows thirty-three years before. Lionel remarked in his diary: "Master made a good speech. I did not."

Ethel was now seventy-eight and whereas Lionel refused to acknowledge old age, it could almost be said that Ethel welcomed it. In some ways she had had a hard life. Lionel being away so much had meant that all the responsibilities and worries of everyday had fallen to her to deal with. Fortunately her sense of humour always enabled her to see the funny side of most untoward happenings and lightened the burden of dealing with them.

She had enjoyed her animals and her garden and was proud of Lionel's successes, always listening with relish to his excited accounts of what he had done and the people he had met when away from home. He always took her criticism of his work seriously, especially with regard to the horses in his pictures. I have heard her say calmly, "That chestnut looks as if it has a broken leg. You must alter it, darling." And Lionel would stand back with a frown, disagree at first, then agree and alter it.

Now, at seventy-eight, time and Lionel's success had removed most of her worries and she could relax—a word she hated, considering that it meant doing nothing with a life which should be full of challenge and fun. But she had become rather frail, tired easily, and found many things no longer important. After the Second World War we had

little help, and as Ethel could no longer garden herself, both house and garden became somewhat neglected, but this did not trouble either of them. The idea of "trying to keep up with the Jones's" would never have occurred to them. They were always happy in each other's company, and one of my strongest memories is of seeing them sitting together on the garden seat which we had given then as a golden wedding present, just looking at the view and enjoying being at Buckholt.

One of the customs which was kept up and which Lionel never failed to note in his diaries, was that of the family Christmas in the studio. It started when we were children and Ethel's small paying guests and their governesses, together with 'the Aunts', Ethel's sisters Cissie and Fanny, who always came for Christmas, made us too many to use the dining room. So Lionel's old table in the studio was cleared of paint, charcoal, harness, sketchbooks and the like, and covered with a huge beautiful damask tablecloth from Benarth days. We never had a Christmas tree. The presents for the entire family were loaded into saddle-bags on Judy the donkey, and when these were full, piled round her on the floor. Judy's behaviour was not always all that it might be, since she frequently ran away with us in the donkey cart, but at Christmas her conduct was always exemplary. She would stand, hidden by Lionel's large screen of Exmoor (brought from the drawing-room), perfectly quiet and without moving while we ate a protracted Christmas dinner, which became noisier as time went on and finished by the pulling of crackers. Judy seemed not to mind either the crackers or the increasing noise as parcels were taken from her and opened. She never moved until, replete with sugar and carrots, she was taken out and returned to her field—where, incidentally, she never stayed unless it suited her to do so. If it did not, she just went down on her tummy and under the wire fence.

Now, in 1958, and for many years after, it was the grandchildren and their parents who sat at the old table, and there was a Christmas tree, for Judy had died many years before. But Lionel and Ethel enjoyed it all as much as ever, and Christmas was always a time of gaiety and happiness.

An idiosyncrasy which became more apparent as Ethel grew older, was the cause both of amusement and sometimes of embarrassment to her family. It was due to her increasing dislike of meeting new people because she was so shy. Her chief pleasure was motoring and she never

seemed to tire however long the journey. She loved to accompany Lionel on his various travels and this often meant taking him to some house were he was to stay while he painted whatever had been commissioned. Whether driven by the chauffeur or by Lindsay or Kenneth, Ethel insisted on being put out on the roadside or in the drive (if it was a long one) before the car drove up to the house. It was sometimes wet or cold, but no entreaty would persuade Ethel to stay in the car. This meant, of course, that the driver had to leave as soon as possible after delivering Lionel and his painting paraphernalia. If Lindsay or Kenneth was driving this was often extremely difficult, as they would be asked in either for a drink or to stay for lunch or dinner. They had to make excuses, sometimes very lame ones, as to why they had to leave immediately. They felt it impossible to explain that they had left their mother, perhaps by now drenched or frozen, sitting by the roadside a short distance away!

This state of affairs only came to an end when Ethel, having broken her hip, became completely dependent on crutches. This meant that she had to remain in the car, from whence her conversations with new people could be terminated quite quickly.

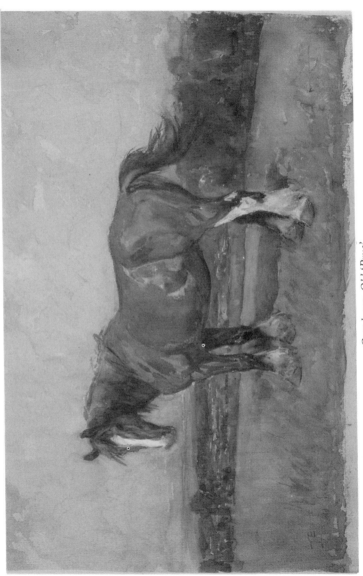

Cart horse, Old 'Prue'.

In his diary for 1st January, 1960, Lionel noted that he already had twenty-two commissions to fulfil before the year started. The volume of work increased possibly, as Lionel rather wryly remarked, because people expected his imminent decease. He painted a great many portraits, both human and equine, the latter including those of "Pas Seul", "Foxhunter", before he embarked for Helsinki and Miss Yule's famous old Arab "Grey Owl".

He still enjoyed painting hunting scenes and landscapes more than anything else and still insisted on doing so out of doors in all weathers. In February, while painting the Whaddon Chase, he wrote to Peter Biegel: "Damned cold, especially Monday, when an unknown farmer's wife brought tea out to me and saved my life." Later in the year he asked me to take him to the Three-Day Event at Tidworth, and though it was a very hot day, insisted on walking the whole course, refusing to acknowledge afterwards that he was very tired. He was, however, eighty-two, and in May took a long time to recover from a bout of 'flu, writing to Peter that although he had several rather urgent jobs coming along, "Like the British workman, I feel all funny at the prospect of work."

In August Ethel was very ill with pneumonia, but recovered sufficiently to accompany him to Scotland later, where he continued to paint every day, out of doors if it was fine and if wet from inside the car.

After Lionel's very successful exhibition at Roland Ward's in 1958, which had been organised by the Hon. Aylmer Tryon, the latter opened his own gallery—"The Tryon Gallery", in Dover Street, and from 1961 onwards he dealt with nearly all Lionel's work except for some prints which were still sent to "The Sporting Gallery" or to Mr. King or Mr. Ling at Messrs. Fores.

Aylmer, who lives not far away, was a frequent visitor to Buckholt,

and spending most of his time in the Studio, was evidently sometimes nearly frozen to death. On one occasion he brought Lionel a fan heater which was always known as "Aylmer". Sometimes if we had an unexpected visitor and Ethel thought the drawing-room a little chilly, she would say to me, "Go and fetch Aylmer, dear," and I would see the surprise on people's faces when I returned with a fan heater.

1961 seems to have been a year in which Lionel was away from home a great deal, and working harder than ever, but I shall always remember it for a very special reason.

Lionel always maintained that his brother artists took themselves too seriously and that apart from the necessity for artistic ability, the chief ingredients for success, as for all worthwhile efforts, were dedication, perseverance and hard work. The artist should not consider himself an especially valuable member of the community. Lionel therefore scorned to possess what is popularly known as 'the artistic temperament', considering it was usually the excuse for behaviour which would not be tolerated in other people. To a certain extent Ethel agreed, but knew that the true artistic temperament is something which its owner cannot help but possess and which therefore has to be taken into account by his family. Lionel was more excitable, more easily exhilarated or depressed, and on occasion more given to outburst of temper (often quite unjustified) than other people. We children kept out of his way until the storm was over. Sometimes he was unjust and unreasonable, but we took little notice, for Mummy would be able to manage him as she managed us. It was 'just Daddy' and we never bore him any grudge, knowing that in a short time it would all be forgotten.

Perhaps it was natural that when he grew old, possibly because he still worked so hard, these periods of stress became more frequent, but Ethel could still manage to calm him. In October, 1961, however, when Lionel had just returned from Scotland, Ethel suddenly became very ill with thrombosis in the artery of the leg. She was in such pain that the doctor put her under heavy sedation and arranged that an ambulance should come early the following morning to take her to hospital. I sat up with her all night, glad that she remained unconscious and so out of pain. I was astonished when at about five-thirty the next morning Lionel came in. He was in his pyjamas, wild-eyed and in tears. He was so incoherent that it took me some time to realise that he was not going to allow Ethel to be taken to hospital. He was sure she was going to die, and they had promised each other that neither should be allowed to die

in hospital, but at home. In vain I protested that Ethel was very likely to die if she was *not* taken to hospital. Finally, I telephoned to Lindsay, who was at Frenchmoor, to come at once. I knew he had had so much experience of illness that his opinion would carry weight with Lionel, and fortunately, before the ambulance arrived, the three of us (Ken and his family were now sharing the house) managed to persuade him to allow Ethel to be taken in it. When I returned home from the hospital with Lionel later in the day he was so exhausted that he slept for more than twenty-four hours.

In due course Ethel recovered but it had all been a tremendous shock to Lionel for he realised that since old age had finally come upon them both, illness was likely to recur, and that they were both, as he often said, "living on borrowed time".

By the end of November Ethel had so far recovered that Lionel was able to hold an exhibition at the Tryon Gallery for which he had been preparing all the year, and which was very successful. It is remarkable that, though he was now eighty-three, thirty-three of the fifty-eight pictures on view had been painted during the last two years.

One aspect of his work in which I have always thought Lionel showed great skill, was in the choice of apposite and original captions for his pictures. One of the finest paintings in this particular exhibition was of horses turned out to grass in the summer and intitled "Golden Evening". Another, a farm scene with two carthouses set in a Wiltshire landscape called "There was peace in the land". Some other titles which at various times I have appreciated were "The Prairie Waltz", showing a buck-jumber trying to get rid of his rider, "Hard words break no bones", depicting two stags roaring at each other across a stream, a picture of a very nasty toss at a Services Point-to-Point at Larkhill, with the title "Let me like a soldier fall", and one which has always haunted me. It is of the horse-lines in France during the First World War and shows a line of miserable, dejected-looking horses huddled together in the wind and the rain "waiting for death" as someone said and entitled "And some there be which have no memorial".

Although he no longer hunted Lionel continued to lead an interesting life. He went to race meetings at Cheltenham and Sandown, to polo matches at Windsor and Tidworth and painted on Exmoor and in Scotland. On one visit to the latter he accepted an invitation from Gavin Maxwell to go to Cambusfearna to see the otters, which on this occasion involved what proved to be quite a hazardous journey by boat.

An event in 1962 which gave Lionel a great deal of pleasure was a presentation at Lockerley Hall (at that time the home of Mr. Hugh Dalgety) to mark his forty years on the Hursley Hunt Committee.

On several occasions, thanks to the kindness of Colonel John Miller (now Sir John), the Crown Equerry, Lionel visited the Royal Mews to sketch the Queen's horses and carriages. In 1963 he was commissioned to paint the Presentation of the Standards by the Household Cavalry. When in July, at the Mews, Lionel was painting the drumhorse on a very hot day, he noticed the sweat pouring down its rider's face, but on remarking on it, the reply was, "Don't worry, sir, I'm quite used to it." In August five men and two horses came to Buckholt as models and it was a strange sight to see one of them standing in the field, his horse motionless, the colours brilliant against the green of the grass and the soldier's breastplate and helmet gleaming in the sun, while Lionel worked at his easel not far away. One day, while in a field close to the lane, a young man jumped out of his van and running across to Lionel, gasped, "Are they real?"

The year proceeded uneventfully until, in November, Ethel, aged eighty-three (Lionel now being eighty-five) broke her hip whilst trying to stop two dogs from fighting. Kenneth had rescued a boxer which he found in one of our fields, and which had been badly injured. We thought he had either jumped or been thrown from a car, and I would think that besides his other injuries, his brain had been damaged, for when he recovered he proved to be an absolute killer, attacking anything in sight. Lionel and Ethel had a very old mastiff to which they were both devoted, and as Kenneth and his family shared the house, great care had to be taken to keep the two dogs apart. Unfortunately, on this occasion, when Ethel let the old dog out, the boxer was on the doorstep, and while trying to separate them Ethel was knocked down and broke her hip. She was, as always, extremely brave and uncomplaining, but for the rest of her life was only able to walk with crutches. Her chief pleasures, since she could no longer garden, were to sit in the studio and talk to Lionel while he worked, and to accompany him on the motor journeys already described.

The night hath not yet come, but it is no longer day.
Cut off from labour by the failing light,
Something remains for us to do or dare,
Even the oldest tree some fruit must bear.

This verse, which I have so far been unable to identify, Lionel wrote in his diary and it seems to me to express his feelings at this time about his life and work. He still painted a great variety of subjects and most of his pictures were as good as ever, although they now took longer to complete to his satisfaction. But in 1964 the knowledge that his sight was beginning to fail and the strain of increasing deafness, began to worry him. He wrote to Denis Aldridge in February: "I realise I have aged a lot in these last twelve months but I cannot grumble. For some extraordinary reason I don't like race crowds these days and unless I have someone with me, prefer to avoid race meetings. I think it is a form of nerves." Later he wrote: "My nerves are all on edge. Ethel is ill and in pain, but never grumbles, being a most gallant old lady."

Fits of depression, however, were rare, and for the most part he continued to enjoy his life and was his usual cheerful self and interesting companion. His beliefs, attitudes and values continued to be very much his own, and had changed little since he was a boy. He had been brought up in a religious household, for his mother and half sister, "Tottie", were both ardent—and very Victorian—Christians. Neither he nor Ethel were regular churchgoers, but both had quite a strong faith and I have often been surprised at Lionel's knowledge of the Bible. He had several Roman Catholic friends and sometimes said that he would like to be a Roman Catholic himself, so that 'the experts', as he called priests, would do his thinking for him. In fact, however, he knew very well he would like no such thing. A trait in

their characters for which I have always admired both parents was their tolerance of the faults and foibles of others. They really lived out one of Lionel's favourite maxims: "Be to their faults a little blind, And to their virtues ever kind."

An odd quirk in Lionel's thinking was that he would never allow us to play cards on Sunday, and in deference to his wishes we never did. Ethel, much amused, said she could see no harm in playing 'Old Maid' or 'Racing Demon' on Sunday or any other day.

Even in old age Lionel never ceased to be a keen naturalist, and enjoyed taking long walks, usually by himself. He particularly liked going out after it had snowed when the tracks of many animals and birds were clearly visible. In a letter to Peter Biegel after one such walk he remarked on the distance cats travel when hunting, on an apparently dramatic increase in the rabbit population, and on the number and variety of animals and birds that had recently passed that way.

In November Lionel had another successful exhibition at the Tryon Gallery and wrote that he had sold forty-one of the fifty pictures during the first three days. He noted in his diary for 1st January, 1965, that he still had five commissions to fulfil before taking on other work. One of these was to paint two horses for the Aga Khan at Easter in Ireland. Lionel was a very bad sailor and hated the Irish crossing so he decided to go by Aer Lingus. It was during my Easter holidays, and as Lionel had never flown before and would have to take a great deal of bulky paraphernalia, he proposed that I should accompany him. We had a very smooth crossing, which Lionel appreciated, but thought it a very dull method of getting from A to B. We were to stay in Aly Khan's house which was not far from the Ballymanny Stud at the Curragh. It had remained empty since Aly Khan's death, for the young Aga Khan was abroad and Princess Joan Aly Khan lived in London. An old lady, a Mrs. Smithwick, was in charge. She was, I think, the widow of a trainer and had looked after the house for many years, judging by the stories she told us of Rita Hayworth and the many other well-known personalities who had been entertained there. Now the house was sad and deserted, but it was in a lovely position, looking out over an unspoilt countryside and with a beautiful lake at the end of the garden beside which Lionel and I would walk in the evening until driven away by a savage old swan who resented strangers near his property. We were told the cob regularly killed all his cygnets unless they could be rescued in time.

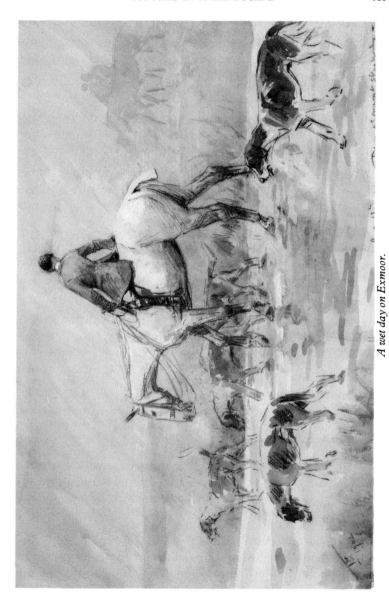

A wet day on Exmoor.

Lionel was to paint two horses at the Ballymanny Stud, "Petite Etoile" and her foal and the stallion "Charlotteville". He painted the mare first. Col. Hall, the stud manager, took us to the field where she was turned out. As the groom held her I thought how well her name suited her. She was a lovely grey with a fragile, fairy-like quality about her, and a gentle, intelligent expression. The following morning Lionel and I returned to the field so that he could finish the background. The mare was grazing and the foal danced and played round her. Having helped Lionel put up his easel and arrange his painting materials, I took a stool and my paperback book to a corner of the field out of the wind. After about an hour I put down the book and walked over to see how Lionel was getting on. When I turned to go back I was horrified to see that the foal had picked up my paperback and eaten more than half of it. Lionel was not worried. "It's only paper pulp," he said, "Can't hurt him." But knowing how valuable the foal must be I watched him anxiously all the morning and was much relieved when we returned after lunch to find him apparently still in excellent health and as lively as ever.

The day that Lionel was to paint "Charlotteville" was very wet and cold and it was arranged that the horse should be painted in a near-by hay barn. I thought "Charlotteville" was one of the most beautiful horses I had ever seen, but he did not like being a model, for which, on such a day, I did not blame him. In vain the stallion man tried to persuade him to stand still for a few moments. He twisted and turned pawing the ground and continually biting the top of the stick the man held for him. Stable lads piled bales of hay against the two pillars nearest the horse and told me it was in case Charlotteville plunged or kicked and injured himself. Unperturbed by disturbances, Lionel quietly got on with his picture (though it was so cold I wondered that he was able to hold the paintbrush) and when it was finished no one could have imagined that his model had been so uncooperative. Fortunately, after this the weather improved. Col. Hall took us to the Punchestown Races, where Lionel sketched the Double. It was a day of sunshine and showers and he noted in his diary "a most picturesque incident, the field (about fourteen) jumping hurdles with gorse as background." He loved gorse! Before we returned to England he also painted on the Curragh near the old Cavalry Barracks, and made several sketches.

I think we were both glad to leave Ireland for although we received great kindness from both Col. and Mrs. Hall and from old Mrs.

Smithwick and her companion, Mrs. Wreford, the servants and villagers remained coldly polite and unfriendly, and there was always a vague feeling of unease which we were glad to leave behind. There was no doubt, however, that his servants remembered Aly Khan with great affection. He must have been a kind and thoughtful person, never forgetting to ask about their children and to enquire after and help any who were sick or in trouble.

At the end of a very busy year, during which perhaps the most interesting picture that he painted was that of "Mill House" and "Arkle" at Cheltenham, two events occurred which gave Lionel a great deal of pleasure. The first was in October, when he and Ethel celebrated their Diamond Wedding. "Think of it," he said to Ethel, "We have been married for sixty years!" Both were delighted with the many letters and telegrams of congratulation they received. The wedding was celebrated quietly at Buckholt, as Ethel had wished. The whole family was present and at the end Lionel made a quite good speech. The second event, a memorable conclusion to a happy autumn, was an invitation to lunch at Buckingham Palace. Lionel had met Prince Philip before, but never the Queen. His ancestors had fought for Charles I and to him the monarchy was a sacred institution and the Queen the representative of all that was best in England. She did not disappoint him. He wrote to Denis afterwards: "When the Queen had finished with the nobs she came and talked to me for quite a while. There is no doubt she has very great charm."

In January, 1966, there was a great deal of frost and snow, and February was wet and cold. Lionel, now eighty-six, stayed at home, except for occasional visits to London and more frequent ones to Salisbury, to buy, from Miss Trott (who owned a little shop, "The Compleat Artist", in Crane Street) the various artist's materials she never failed to obtain for him. Lionel was never idle. He wrote letters and articles, finished sketches, decided which pictures should be sent to the forthcoming exhibition at the R.I. (The Royal Institute of Painters in Water Colour), fixed the dates when he would fulfil commissions, and arranged for another exhibition at the Tryon Gallery in November.

In March, although it was still very cold, Lionel went to paint a hunting picture in the Cotswolds. He was very depressed when he returned. When he had finished the background he had been asked why he had left out a church which, although in the distance, was a well-known landmark. Lionel had to confess that he could not see so far and so had not known it was there. Later in the month he went to see the Cheltenham Gold Cup. The Duke of Beaufort introduced him to Ann, Duchess of Westminister, who took him into the paddock, where he was able to make several sketches of "Arkle". He watched the race, in which "Arkle" was an easy winner, but was worried by the race crowd, and glad to get away quickly afterwards.

At the beginning of April, during my Easter holidays, I was planning to go for a long ride with a friend, starting from Buckholt. We intended to make our way in a leisurely fashion to the Marlborough Downs stopping each night at some inn or farm where the horses could also be accommodated. I had done this before, riding with a cousin from Buckholt to Bridport. Now, as on that occasion, Lionel was interested and helpful. He came with me in the car to choose places suitable for the horses, helped me to decide what food we should take for them,

and—most important—decide on methods of transport—what should be taken by car beforehand to await our arrival, and what we should expect to be able to carry with us on the horses. We were to start on the 13th and Lionel spent the previous evening trying—and failing—to fix two old military saddle-bags to my saddle. He had already had a busy day, helping among other things to deal with the stable drains, which had become blocked. He did not seem tired and told me that he expected to go to Wales while we were away, to paint a portrait. But early the next morning he had a severe stroke and died shortly afterwards. Like Anthony Trollope he could have said:

"I rode hard, to the very end."

Some weeks later I found a letter written by Sir Gerald Kelly to Lionel after the death of A. J. Mummings, in which he said: "I was told that he had died in his sleep. I had seen his crumpled hands, which could not hold a brush, and they told me how he admitted that he longed to die. Physical disabilities make old age a terrible thing, so I was glad to hear of his death."

I could only feel grateful that Lionel had been more fortunate. He had not yet been seriously troubled by the disabilities of old age, and the end, when it came, had not taken long.

The funeral was private and we did not have a memorial service because we thought it would be too great a strain for Ethel, for whom, of course, Lionel's death had been a tremendous shock. She survived him for two years but I am afraid they were not happy ones. I was away all day, Kenneth was out on the farm, and in spite of the kindness shown to her by Nancy, Ken's wife (who was never too busy to answer questions or to listen to oft-repeated stories) and the care taken of her by our Irish housekeeper, she seemed to miss Lionel more every day. For many months nothing in the studio was moved, and Ken has told me how sometimes when he looked in through the windows as he passed, he would see her in there, just standing, looking and remembering.

There was Lionel's winged chair, in which he always sat, still in front of the easel, some canvases and unfinished paintings stacked against the wall, his untidy desk, and the old table, still covered with a muddle of water jars, paints and brushes, paper and sketch books, odd pieces of saddlery and old copies of *Country Life* and *The Field*. All was as it had always been except that Lionel was not there.

It was also a great sadness to her when she realised that eventually Buckholt would have to be sold. Lionel had stipulated in his Will that this should not happen during her lifetime, but he had understood, as she had not, that afterwards it would be inevitable.

I believe therefore that Ethel was quite ready to go, when in 1968 she died peacefully, after a heart attack. She was a gentle person, with a quiet courage and indomitable spirit, and a great love for children and animals. She also loved poetry, and one of her favourite verses from *The Ancient Mariner* best describes the way she thought and our memories of her.

> "He prayeth best, who loveth best
> All things both great and small,
> For the dear God who loveth us
> He made and loveth all."

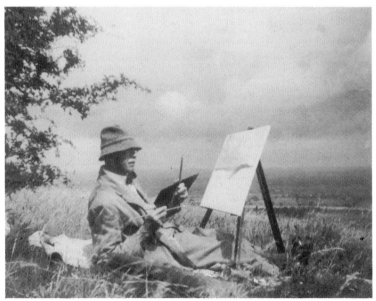

Lionel Edwards, photographed by Frank Wallace, in the twenties.